ARE YOU *CAUGHT IN AN ABUSIVE RELATIONSHIP?*

- DOES YOUR PARTNER CRITICIZE EVERYTHING YOU DO SO THAT YOU FEEL YOU CAN'T DO ANYTHING RIGHT?
- DO YOU FEEL AS IF YOU HAVE TO "WALK ON EGG-SHELLS" AROUND YOUR PARTNER?
- ARE YOU ACCUSED OF HAVING AN AFFAIR IF YOU COME HOME FIVE MINUTES LATE?
- DOES YOUR PARTNER TRY TO LIMIT YOUR CONTACT WITH YOUR FRIENDS OR FAMILY?
- ARE YOU DISCOURAGED FROM TAKING A JOB, GOING TO SCHOOL, OR SEEING A COUNSELOR?
- HAS YOUR PARTNER EVER HIDDEN OR DESTROYED SOMETHING THAT MEANT A LOT TO YOU?
- DOES YOUR PARTNER EVER CURSE AT YOU OR CALL YOU NAMES?
- HAVE YOU BEEN PUSHED, SLAPPED, PUNCHED, PINCHED, OR KICKED?

IF *ANY* OF THESE SITUATIONS SOUNDS FAMILIAR, YOU MAY ALREADY BE CAUGHT IN AN ABUSIVE RELATIONSHIP.

GET INSIGHT, UNDERSTANDING, AND HELP IN—

THE SPIDER AND THE FLY

THE SPIDER AND THE FLY

Are You Caught in an Abusive Relationship?

Ruth Morgan Raffaeli

A DELL TRADE PAPERBACK

A DELL TRADE PAPERBACK
Published by
Dell Publishing
a division of
Bantam Doubleday Dell Publishing Group, Inc.
1540 Broadway
New York, New York 10036

Library of Congress Cataloging in Publication Data
Raffaeli, Ruth Morgan.
The spider and the fly : are you caught in an abusive relationship? /
Ruth Morgan Raffaeli.
p. cm.
Includes bibliographical references (p.).
ISBN 0-440-50733-2
1. Psychological abuse. 2. Abused women—Life skills guides.
3. Abused men—Life skills guides. 4. Abusive women.
5. Abusive men. 6. Relationship addiction. I. Title.
RC569.5.P75R34 1997
616.85'82—dc21 96–53467
 CIP

Printed in the United States of America

Published simultaneously in Canada

September 1997

10 9 8 7 6 5 4 3 2 1

BVG

For my children and their world

CONTENTS

Section III: Getting Help

Section IV: So You're Free; or Are You?
How to Keep from Falling Back into
Your Old Relationship

Section V: Following Up

INTRODUCTION

I have written this book for you if you have ever suspected that someone you love is not truly on your side when you:

- —begin to feel you can never do anything right, because your partner criticizes everything you do, or
- —feel oppressed instead of valued and appreciated, or
- —are discouraged from leaving the house to take a course or a job or going out with a same-sex friend just to talk, or
- —have just found out that your partner has hidden or destroyed something you deeply treasure, or
- —are accused of having an affair when you're five minutes late coming home from work or from the store, or
- —you've been pushed, slapped, punched, or kicked as you are cursed with vile language usually reserved for a worst enemy.

And much, much more. The examples are endless. The ones I have given are common and happen at some time during most abusive relationships to people who are being verbally and/or physically abused. Physical abuse can go all the way from punching and kicking into the terrorism of Russian roulette,

rape, sexual maiming, and being threatened with a knife at your throat.

Did I hear you say just now that only one or two of these things have happened to you and that you have never experienced some of the more serious things I have mentioned? If *any* of these descriptions rings true for you, you are probably being abusively controlled, invisibly isolated, and seriously damaged. I have written this book for you if you are caught in an abusive relationship at any level.

Physical and sexual abuse are the most dangerous in terms of possible loss of your life, and call for the greatest caution in order to keep you and your children safe from harm. But verbal abuse and other abusive behaviors are also devastatingly destructive of individuals and families. The pain from an abusive relationship is felt physically, emotionally, mentally, and psychologically *no matter how or by whom* it is administered.

What I have said here applies to any adult, whether you are being abused by a male or female, parent, adult child, lesbian or homosexual lover; whether you are being abused once a year or once a week, or every day. It applies to any action used by one person to oppress, intimidate, control, or confine another.

You have some choices. You can wait until you are brutally forced out of the relationship and badly hurt, or worse. Or you can read here how you can:

—understand your "love" partner and your relationship;
—gradually recover the spirit and resolve and physical stamina you need to refocus your life;
—learn more about what your choices are (right now you may be living in a fictional realm of limited and restricted choices);
—draw your own individual road map to a better life, past barriers and obstacles that are stopping you now;
—learn how to recognize the early signs of abusive treatment so you can avoid the next abusive relationship.

In this book I will refer to an abusive person as "he" and the abused partner as "she," even though I am aware of the fact that abuse is taking place in many kinds of relationships. I've done this partly because my original research was carried out in the context of male-to-female battering; partly to honor the fact that in most cases the most serious physical damage is done by men abusing women; and to avoid tedious referrals to "she or he" throughout the book. The behavior of most people who are caught in an abusive relationship tends to be strikingly similar, including their patterns of communication. Abusive people exhibit many of the same patterns of action, and their abused partners react to them in ways that are common to most people in their situation. Some of the stories I have told in this book are composites of two or more similar incidents. In each case the names of both women and men have been changed.

If you are being abused, you can't afford to wait for your partner or our social system to change. In the end it is up to you to change how you perceive your situation and change what you do about it. There is no one else who can do it for you. Only you have the power to gather your resolve, make a choice, and take action. But once you make the first phone call, *you don't have to do it alone.*

I have deliberately focused on you and what you, with help, have the power to do, rather than on your abusive partner and what he is doing to you. I have done so to make it easier for you to do the same thing.

I spent a year working in a shelter for battered women to gather information about domestic violence. I interviewed abused women who used the shelter as a refuge as well as those who never had the privilege of learning the valuable lessons a shelter can teach. I interviewed women who experienced verbal, physical, and sexual violence, or were victims of other kinds of abuse. I talked to women who stayed out of abusive relation-ships after escaping the first one(s) and those who did not; and

to those who narrowly, but proudly, escaped their next brutal connection with a man. I talked with an elderly mother who was being abused by the daughter who was taking care of her. I talked with a young woman who had been repeatedly beaten by her mother and brother, and more recently by her four-year-old daughter who had begun to add her tiny fists to the blows her mother received. I talked to several men who were abused by parents and by partners. I did this to check the patterns of abuse I was finding; to see if they were similar regardless of the relationship. They were.

My research on domestic violence was done in order to identify abusive patterns of communication; to find out how human interactions interlock and abusive patterns form.

The title, *The Spider and the Fly,* is a metaphor that refers to the relationship between an abusive man and his partner. The spider, or the abusive person, almost instinctively spins a web to capture his prey in order to fill his needs. The spider, not as free as he seems, is held at his post to watch and repair his web so that it will be attractive (or invisible) enough to catch her in it; and strong enough to hold her there. Once his prey touches the web and is caught, each move she makes in her struggle to be free only tightens the strands of the web that holds her.

Neither one of them is free to leave the relationship.

My hope is that someday everyone will be so well informed about the early signs of an abusive relationship that she will be able to pick up the telephone and call for advice and help before she has been isolated, threatened, or hurt; before she is caught in the web. If we fail to learn and implement all possible preventive measures to discourage violence in our society, there won't be enough shelters to hold us all.

For the most part I have not identified abused people as either victims or survivors, because I hope you will not continue to identify yourself with abuse at all. There is much more to you than that. Maybe, for now, you can simply identify yourself as a work of art in progress: a handsome, powerful lump of

colorful, exotic clay. The ultimate design and function of the finished product is in your hands.

Here's to the joy of finding out what you can do and who you can be.

<div style="text-align: right">

Love and joy to you,
Ruth Morgan Raffaeli

</div>

Open Letter to those of you who care about someone who is caught in an abusive relationship and feel helpless because you don't know what to say to her or do for her:

Dear Concerned Person(s):

This book was written to reach into the isolated hearts and minds of people who are locked in an abusive relationship. Such people may sometimes find a book like this for themselves. But sometimes they may be so isolated that it is unlikely that they will find it by browsing in a bookstore. It may not be safe for them to be there.

Sometimes this book may be given to an abused person by someone like you so that you can say the things you would like to say if you knew the words to use. But it will have little value unless you offer four more gifts: 1) a private, secure place to read, away from the anxious and suspicious eyes of an abusive partner; 2) a chance to discuss the book with you or perhaps compare answers to the worksheets; 3) the telephone number for the hotline for battered women; and 4) an offer to use your phone and the privacy to talk.

Please don't be disappointed if the abused person in your life doesn't seem to be interested at first. Don't force the issue. You can try again at a later date. You may be surprised when the person you are concerned about eventually asks you for the book. Stay safe, but don't give up.

An abused person may be endangered just by having this book in her personal possession, or in her own house. With your help it will be possible to reach many more silent, hidden people who are being abused.

Sincerely,
Ruth Morgan Raffaeli

THE SPIDER
AND THE FLY

SIGNS AND SYMPTOMS OF AN ABUSIVE RELATIONSHIP

How to Avoid the First Blow: Recognizing Early Signs of an Abusive Relationship

It's easy to fall in love with an abusive man. The abused women I talked with during my study had done exactly that. Of course, they had already fallen in love by the time they realized their boyfriend was an abusive person. Francine was one of the women who told me how she had been trapped and drawn into a relationship that started with romantic interludes and ended in severe verbal and physical abuse. Francine's relationship with Derek ended with a deadly game of Russian roulette ten years after its romantic beginning. She told me about the beginning of her romance with Derek. And without either one of us knowing it at the time, she taught me how an abusive person acts in the early stages of a relationship. I was to hear the same story many times over as I continued to talk to abused women.

Francine had just graduated from high school when she first met Derek. He picked her up and took her to work every morning; picked her up at noon and took her out to lunch; and then he came for her after work and drove her home. He was always there. He called her on the phone when he couldn't be with her in person and often sent her flowers, notes, and candy. He even took her to the mall and bought clothes for her. They used to go to the park and hold hands and walk in the rain. Francine said,

"We used to go out to dinner all the time. We used to go to the zoo. We used to do just oooooh, just oooooh!"

Francine was enthralled with the attention Derek was paying to her. She never had to wait for him to call her, or doubt that he loved her. Indeed, what could be wrong with this relationship?

Even in this early enchanted stage of a relationship, it is possible to tell whether or not your new boyfriend will be abusive in the future. You can learn the early signs of an abusive relationship, and get out of it before he threatens you for the first time; before you are afraid of what he will do if you try to get away from him. You can get away before he strikes the first blow, either verbally or physically. And you can avoid being weakened and changed by his abuse and your reactions to it before your ideas about who you are and what you want have been damaged.

You might not be able to tell whether he will attack you with words or fists or both, or how soon he might attack. But you can learn to recognize a pattern of communication (talk and action and your reaction to them) that can identify people as abusive. Learning these early signs can save you years of living with a partner who is not truly on your side, although he is good at pretending he is.

I will describe two sets of symptoms of abuse. One set identifies signs of an abusive person; the way he talks and acts. The second set of symptoms are your own reactions to abuse. If you are going to prevent yourself from being hurt by an abusive relationship, it is important that you learn to recognize your own reactions. And they may be easier for you to identify.

What Are Some of the Things an Abusive Person Might Do When You First Begin to Date?

1. Exaggerated attention. Derek's need to control and possess Francine took the form of charming around-the-clock attention. This is easy to spot, but it's hard to believe it is the

beginning stage of abuse. Even years later Francine was pulled back into the relationship more than once by the memory of those idyllic early weeks and months she spent with Derek. She convinced herself, over and over, that it really could be like that again.

Other women reported similar experiences in the early stages of relationships that would later become abusive. Charlotte told me, "Oh, it was great! Because, see, everywhere he went, he wanted me to go [with him]." And Linda said, "He was sweet, kind, and loving. It was like I met my knight in shining armor." Both men later became severely abusive.

Your new boyfriend may also lavish attention on your parents, your children, and your friends, offering his help with anything they need to have done. Battered women often say about their partners, "He will do anything for you." This seems to be part of his plan to impress and act "the good guy" in front of your friends and relatives, at least in the beginning.

2. Possessiveness. As Francine and Derek's story shows, exaggerated attention usually slips into possessiveness. Derek was paying so much attention to Francine that she didn't have time to do anything else but to see him, or talk to him on the telephone. He monopolized all of her spare time and attention. He wanted all of Francine's attention for himself. And Francine confused possessiveness with love. She said, "I would say he did love me at that time. . . . It was like I became his possession. He owned me."

This "cocoon of love" is consuming. It can feel like every woman's dream of the perfect man and the perfect relationship. You may find yourself thinking, as Francine did, "I will never be lonely again."

3. Jealousy. The actions of your new boyfriend can easily flow from exaggerated attention and possessiveness into jealousy, or the habit of watching over you with unreasonable suspicion and apprehension, lest you should become interested in, or even come in contact with, someone else. If you work or go to school, he may begin to ask you questions about your male

co-workers or your fellow students. He will probably want to know if any of these men have asked you to go out with them. He may accuse you of flirting with them or trying to get their attention.

It is very common for an abusive man to object to the way you dress when you are going somewhere without him (or with him), saying you wear revealing clothes so you can catch the attention of other men. His jealousy often includes your interactions with women as well as with men.

It was when Derek drove Francine to the recreation center one day that she first saw how jealous he was. She was going to play tennis with a few girlfriends. Derek went into a rage when he thought of other men seeing Francine in her short shorts. He later calmed down and told her to go on and have a good time.

These three signs of an abusive person, attention, possessiveness, and jealousy, often appear all at once. They can twist together into a cord that often restricts every move you make and every word you say.

4. Abusive talk aimed at you. The same signs that indicate possessiveness and jealousy—your boyfriend's questions and accusations about where you've been and who you've been with, as well as his comments about how you act—are verbal abuse. Yes, this *is* verbal abuse! It's hard for you to notice this first verbal assault because you are naturally paying more attention to your own explanations than to what *he* is doing.

There are many forms of subtle, hard-to-spot abusive talk that may begin early in the relationship. A few examples are: 1) Your boyfriend may discount your opinions or simply not ask you what you think about anything; 2) he may make gentle fun of you and little things you do, especially when you are around other people, sometimes being sarcastic or mocking; 3) he may begin to forget to give you a compliment or forget to apologize when it would be appropriate (it's easy to identify an insult as abusive, but the absence of a compliment or apology is harder to spot); or 4) he may simply become more unpredictable as his

moods change without warning. He may sometimes still be attentive, but suddenly turn more silent, cold, or angry.

Most of the time, however, he will probably act as charming and attentive as ever. Unless you are aware of some of the subtle things he does and says, it will be hard for you to notice when he becomes more abusive. Pay attention to your own reactions. Notice when he says things that surprise you or hurt you. Just because your boyfriend is not raising his voice to you, cursing, insulting, accusing, blaming, and criticizing you, does not mean he is not already being abusive.

5. Criticizing other people. The critical nature of an abusive man may show up first in his criticisms of other people. He may criticize his or your relatives or friends. He may object to anything about them, usually something unimportant and petty, such as how they dress, how they wear their hair or hold a cigarette, or their choice of boyfriends. But if he is this critical of your friends or relatives, you can be sure he will criticize you eventually, no matter how "perfect" you think you can learn how to be.

6. Competing with you for attention from other people. Early in the relationship this characteristic is hard to spot, and it is expressed in subtle ways. Examples of early competitiveness include:

- If someone else comments on how nice your hair looks, he may ask for a compliment about his own appearance. Or he may claim the credit for your new hairdo as his own, and say something like "I was the one who suggested she have it done that way."
- If you are praised for something you've done, he may call attention to his own accomplishments.
- If you work hard at something and someone praises you for it, he will talk about how hard *he* works.
- You may begin to notice that he seldom offers *you* a compliment. It doesn't fit in with his competitive mode.

This kind of subtle competition is another clear warning to you that *he does not have your best interests at heart.* It demonstrates that he is so centered on his own needs that *he can't be generous in the emotional support he offers to you.* It bothers him when you get the attention he wants for himself. It is a form of jealousy or envy. Competitiveness is a major early sign of an important characteristic of an abusive person, and that is: *he is not on your side.* Many of the abused women I talked with had suffered a lot of abuse before they realized that their partner was *not truly on their side, but was very good at pretending that he was.* This is such an important point that I intend to repeat it throughout the book whenever it needs to be reemphasized.

Later on in your relationship, competitiveness can show up as a problem when you are raising your children. Instead of joining with you in teaching your children how to live, he will be more likely to compete with you in his efforts to be their favorite parent.

If you don't recognize these early actions, questions, criticisms, jealous accusations, and competitiveness as abusive, you are not alone. Even though the women I talked with were the source of my information, they had not recognized these habits of personality as being abusive either. It was only after I heard many stories from many women about their courtship with an abusive man that these patterns became clear. It is hard to be objective when you are part of the relationship.

Now that you have some of the early warning signs of how an abusive person acts, do you think you will read this all-too-brief list of what he is like and say, "Aha! thank you, I'm grateful. Now I must end this relationship right away"? Probably not. That's asking too much of yourself. It's more likely that you will read what I have said about the way he talks and acts and tell yourself that you know you can control and change both the relationship and your new boyfriend; that you can make it turn out differently this time. You will probably have this kind of dialogue with yourself even if you suspect that he

has had violent relationships with other women in the past. Maybe he even has a history of violence with his own mother, as many abusive men do. Of course you want to deny that this is not the right man for you. After all, it feels so nice and so right, doesn't it?

Linda found out how strong her denial could be when an advocate from a battered women's shelter took her downtown to show her the computer records the Justice Department had on her abusive partner, Tom. She said that she stood there staring at Tom's criminal record of abuse of other women, including his own mother whom he had abused repeatedly. She said, "I'm down there arguin' with the judge and everybody else, [saying,] 'No, he didn't do it, he didn't do it.' " Linda had come into the shelter with multiple bruises and severely blackened eyes and yet she was still denying that it was possible that her partner had a record of being abusive.

Linda said, as most abused women did, "I guess basically, underneath it all, I did love him . . . and I just didn't want to turn it loose."

This kind of strong denial, one of your first reactions to being abused, is typical of many abused women. That's why taking a look at some of your other defensive reactions, and the kind of person you are becoming, may help you to lift the veil of denial and increase your awareness about the kind of relationship you are dealing with.

What Are Some of Your Early Reactions to an Abusive Person?

In some ways, many women are more frightened by their own reactions to living with abuse than they are of the abuse itself. It was when Annette saw her own hysterical reactions to Charlie later in their relationship that she was galvanized into action to change her life. Your own reactions may certainly be easier for you to identify than his early abusive behavior.

Even in the early stages of knowing this new man, you may

have noticed that you are already beginning to change into a person you hadn't planned to be. Some of the ways you may react to him (or defend yourself against his abuse) include:

1. Overexplaining. If you find yourself spending a lot of time explaining things to a new boyfriend (like where you have been or what you've been doing when you are not together), be careful. You are showing one of the most important symptoms that tell you: "Right at this time at least, and with this man, I am vulnerable to being abused; I probably *am* being abused." You may find yourself explaining the smallest of your actions, like why you made a certain remark that you thought was innocent, why you ordered a certain dish in a restaurant, or why you do or do not wear fingernail polish. Be aware of your answers to his probing questions. Each time you offer an extended explanation for an innocent action, more of your Self seeps away.

2. Apologies are closely related to explanations. Linda said of her own reactions, "I'm always apologizing; always saying, 'I'm sorry.' You would think it was *me* who was accusing *him*" of trying to attract another person.

3. Efforts to please. Women often lose themselves in their increasing efforts to please someone who cannot, in the end, be pleased. Francine gave up her ambition to be a practical nurse when Derek insisted that she drop her courses. Later he asked her why she didn't want to make something of herself. She had tried to please Derek, but typically he found something to criticize anyway. You should not have to give up your Self, or your plans for yourself, to have a fulfilling relationship with a man. The best relationships are those where two people can sincerely support the interests and activities of their partner, while at the same time joyfully sharing their mutual interests.

4. Your own feelings of self-satisfaction. When you hear your boyfriend criticize your relatives and friends, you may hear a small voice in your head say, "I'm glad I don't act that way." This self-satisfied reaction is often the beginning of your consuming efforts to please him; of trying to be perfect for him—

to prove that you are not like those other people that he is criticizing. It's like saying to yourself, "Be careful what you do, you don't want him to say things like that about you." Your feelings of self-satisfaction can be the beginning of trying too hard to please someone else and then losing track of what kind of person *you* want to be.

All of us strive for self-improvement. But there is no such thing as becoming perfect. The target is too elusive. There are too many scales of perfection: your own, your boyfriend's; your friends' and relatives'; your job goals; and the expectations of society at large. Even your own idea of perfection for you will change as you enter different environments; as you mature; as you take on new relationships. Your own idea of what kind of person you want to be is tough enough to work toward, without being distracted from it by someone else's idea of what you should be. Keep in mind that there is no such thing as a perfect human being. Abusive people, however, often adopt an attitude that they themselves "can do no wrong."

Helen's husband, John, said to her during their first week of marriage, "Now, if you would just iron my pajamas and my underwear, you would be a perfect wife." A little later he told her that there was a list of about five things he wanted her to change in order to be perfect. The list soon expanded to ten things. Helen was working at a full-time professional job. While she was busy ironing his pajamas, it seemed she didn't have enough time to make all his dinners from scratch like he wanted her to, or comply with all the other things on the growing list. She became so mired in trying to meet his expectations of her that she lost track of her expectations of herself. She lost track of what was reasonable and what was not. It never occurred to her to hand her husband a list of changes she wanted him to make to be perfect for her, or to hand him the iron when he wanted his underwear ironed.

She knew that as far as she or anyone else was concerned there was really no such thing as perfection. She considered the search for perfection to be an individual's gift to herself. But as

she became more isolated with John and lost contact with her friends, she continued to try to meet John's expanding list of goals of perfection for her. Helen's Self became weakened to the extent that when she had babies, she even tried to iron their diapers as her husband demanded.

5. Misinterpreting his possessiveness as love, and his jealousy as caring. You may feel flattered by his possessiveness and jealousy in the beginning of the relationship, believing it's a sign of how deeply he cares for you. It's more likely a sign that he thinks he has a right to watch over you—to possess and control you.

How Can You Tell the Difference Between Abusive and "Normal" Behavior?

The exaggerated attention in the beginning of an abusive relationship, and the "cocoon of love," are very attractive aspects of this relationship. All relationships that begin with extravagant attentions may not be more overtly abusive later. It depends on the degree and kind of attention, possessiveness, and jealousy and whether there is any abusive talk or competitiveness. It depends on the whole picture. Both men and women show some possessiveness and jealousy in almost all of their relationships. Here are a few ways you can tell when a new relationship is very likely to be abusive:

1. If abusive talk is part of the relationship, there is no need to ask yourself any further questions. If you hear accusations and criticisms, put-downs or blaming of yourself or anyone else, don't assume they will go away. It doesn't matter how mild or how subtle you think they are. Abusive talk can also be disguised as a joke, as sarcasm, or as exaggerated, controlling attention. Subtle abuse is often characterized by his disrespecting you and what you think or what you want, or manipulating you to keep you under control; getting you to do what he wants and not what you want. Even the milder forms of abuse

often worsen with time. The abused women I talked with could look back over their relationships and see that the kinds and frequency of abuse they suffered had increased as their relationships continued.

Try to spot this abusive person before the relationship goes any farther.

2. Assuming you haven't heard talk that sounds abusive to you, then how do you tell the difference between an abusive trap and the relationship you've always wanted?

First, check your yes or no answers to the following questions and then think carefully about what your answers mean to you and how the answers fit in with the kind of life you have planned for yourself. Every time you answer yes to one of these questions, the chances that you are in an abusive trap increase:

Yes No
- ☐ ☐ Have you noticed you don't have time to see your girlfriends as much as you used to?
- ☐ ☐ Did you love to read, write, or draw before you met your new boyfriend, but haven't had enough time to yourself to look at that new book you've heard about?
- ☐ ☐ Do you feel even a slight sense of annoyance when he begins to "hover" over you when you want just an hour or so to yourself so you can think?
- ☐ ☐ Is he watching over so many of the details of your life that you have begun to wonder why you feel your life is slipping out of your hands?
- ☐ ☐ If you spend time with your hobbies, your family, or your friends, does he show signs of being jealous, try to pull you away from them, or persuade you to spend that time with him instead?

3. If your answer to any of these questions is yes, and you think you might be slipping into an abusive relationship, it's time to try a few easy tests.

The tests I am going to suggest are not manipulative. They

are just one way you can highlight any abusive traits your boy-friend may have so that you may become more aware of them. The results can tell you whether or not it might be a good idea to keep on dating other men. The first tests I suggest all involve making plans to go somewhere or do something that do not include your new boyfriend.

- Plan a situation where you are going to be doing something with one of your closest girlfriends. (Leave guys out of this test. Any man could be upset if you go out with another male.) If he reacts by saying sincerely, "Oh, good, I hope you will have a good time," you are probably, but not necessarily, on safe ground. Does he ask you a lot of questions about where you're going or what you're going to do? If you are going to a restaurant he might see threatening possibilities of losing you to someone else, and then he is likely to react in an obviously jealous way.

 One of the things he might say that can alert you to explore further is "Why don't I get your girlfriend a date with one of my buddies and we can all go together?" Under these circumstances a possessive, abusive man would rather double-date than see you go off on your own, without him.

 Or he might ask you, "Where are you going?" And then when you get there, you may be surprised to find he has followed you, or arrived there ahead of you.

 As you are getting over the surprise of seeing him there, he may say something like "You made it sound like so much fun, I thought I would enjoy coming here too." He might even show up with another girl.

 He is good at making all of this sound so reasonable. Who could doubt his motivation? He might tell you, "I was lonely and I just wanted to be with you." It's easy to melt at the sound of his words and forget your doubts—many women do. But this relatively mild stage of abuse is very controlling.

Gaining as much control over you as possible appears to be one overriding motivation of an abusive person. In the beginning, however, his efforts to control your life can be nearly invisible. And each time you defy his controls or restrictions, or defend yourself against them even in small ways, his fear motivates him to tighten his efforts at controlling what you do. Then, each time he tightens his hold on you, you have more reason to rebel and then, of course, he must restrict you even more. What he appears to be most afraid of is losing you. These interactions continue and deepen as the relationship continues. This cycle of control on his part and your defense against it is one thing that escalates the severity of abusiveness in a relationship. And it is quite common for anyone to defend herself against being controlled by another. Can you see that once you are caught in this cycle it becomes harder to find a way to untangle yourself from it?

Listen carefully to what he says. The clues he gives you early in the relationship will not be obvious. You will need to put the pieces together yourself.

• A second test you can try is to tell your boyfriend you want to go for a walk by yourself and just relax and think. He may make a remark like "Why would you want to do that when you have a nice boyfriend like me to walk with you?" or "I will take you wherever you want to go." Again he shows that he has no respect for your choices; that his need to watch over you overrules what you want to do.

If this happens and you find yourself explaining to him why you want to walk alone, stop and think seriously about whether or not you want to continue this relationship. Both his action (exaggerated attention and possessiveness) and your reaction (explaining) are flags of warning that say, "This man is abusive!"

• One other simple way to check on the extent to which you are being possessed is to observe what your new boyfriend

does with the time he is not spending with you. If you notice that 1) he has dropped most of his other activities (hobbies, sports), and that 2) he has no close men friends with whom he spends at least some of his time (drinking buddies he sees only in a bar or during drinking sessions don't count as friends), and that 3) seeing you is the way he spends most of his spare time, be aware that he is being uncommonly possessive. He may even reach a point where he cuts short the time he spends on his work or career. This can be a symptom in him that says, "I need more time to watch over you, to control and possess you."

Irene told me that a little later in her relationship, after they were living together, her partner, Larry, began to stay home from work. At first she thought he was staying home just because he didn't feel like going to work that day. But, she said, "now when I look back, I see what he was doing." Irene said Larry would just stay home and "guard me . . . and watch me . . . what I was doing . . . who I was talking to on the phone."

This kind of attention and possessiveness are abusive because they deny you the right to make your own free choices about where you're going and what you are going to do, when, and with whom. He has no right to interfere in your life to that extent. It doesn't make any difference whether you have just met him or have progressed to the point of getting engaged to be married, or have been together for years, you still have a right to plan some of your life's activities without him, just as he has the right to plan to go places and do things without you. Most abusive men don't understand that. They think they have a right to be free—to come and go as they wish—making no explanations to anyone. But they do not appear to believe that you have that same right.

• To check on his competitiveness, ask one of your girl-friends to offer you a compliment on your clothes, or your hairdo, in his presence. If he says, "How do you like *my*

new shirt [shoes or haircut]?'' or something similar, you may want to keep on dating other men.

These patterns are the building materials for an abusive relationship, whether it stops at the use of words, or continues on to involve physical attacks.

The tests I have suggested are simple, and you can probably think of more that fit your personal situation exactly. Don't hesitate to try them, but be careful how you do it. You'll be safer if you stay casual and don't challenge your boyfriend, no matter how he reacts to your attempts at independence. If you suspect that he is an abusive person, it's not a good idea to tell him about your doubts. You can't expect him to understand that his behavior is abusive. Abusive men often deny they are doing anything wrong even after they are forced to look at their behavior by the courts.

Even in the beginning of your new relationship, your contacts with many of the other people you usually interact with have begun to be restricted by your boyfriend's attention, possessiveness, and jealousy. Your own fear of what he will say or do when you try to contact other people is also restricting you. That means there will be fewer people to whom you can freely and fearlessly express your doubts about this new relationship.

Although she wasn't aware of it, Francine was already isolated from her friends at the time she was trying to decide whether or not she wanted to continue her relationship with Derek. If she could have talked with someone then about the way Derek was acting and about her own doubts, it might have been harder for her to ignore her own feelings. It might also have been clearer to her that this man and this relationship were not the only solutions to her loneliness. She tried to break away once when Derek became more painfully possessive. She wasn't strong enough to do that alone. She needed help and support from other people and she didn't have it. Derek had done a good job of breaking her contacts with her relatives and friends.

If you are concerned that you may be stepping into an abusive relationship and you want to discuss it with someone, this is a good time to make your first contact with the hotline for battered women and the trained people you will talk with when you make that telephone call. Your call will be welcomed and taken seriously, whether you have been physically hurt yet or not. Don't feel shy about calling. This is the ideal time to talk with someone who knows what abusive relationships look like in the beginning. It can keep you from slipping into isolation, or it can give you a hand out of isolation if you are already there. Your doubts are valuable. Trust yourself and use them to stay safe. See the "Resources" section in the appendix in this book to find out how the hotline number in your local telephone book may be listed; or look to see if your state has a hotline number. When there is no local hotline available to you, call the national hotline (also listed in the appendix). That's what it's for.

If, with the help of the trained people you talk with, you decide you want to break off your relationship, don't mention it to your boyfriend until you have resolved all of your doubts and you are ready to state your decision in a firm, clear way and are prepared to stick with it. Without this kind of informed support behind you, it can be hard to make such a decision and stand by it. Your boyfriend is likely to be very good at knowing how to persuade you to stay in the relationship with him.

Before you talk to him, telling him of your decision, have a plan for where you will go as you leave him, and then go there as soon as you have told him how you feel. It's a good idea to meet him in a public place and have a good friend with a car waiting to pick you up when you leave.

Even though you may not yet have seen the cruel or dangerous side of your boyfriend, this is one time you are likely to experience it. When he hears evidence that he is

losing his control over you, his fear will likely make him more desperate to keep you. Without warning he can become more threatening and intimidating. It may not happen this time, but be prepared for it.

In the metaphor of the spider and the fly, this early period of courtship represents the time when a woman first touches the web, unaware, and becomes entangled in its strands. Sometimes it is only when she tries to escape that she realizes she is caught.

More and more women are learning how to get out of an abusive relationship before they've lost themselves, and before they are likely to be stalked or hurt. May you be the next one.

The Invisible Trap:
Social Isolation

If you can't pull yourself out of isolation with your partner, you won't be able to pull yourself out of an abusive relationship, even in the beginning. That's how important and powerful the effects of isolation are, and yet few people are aware it is happening to them. Social isolation is invisible and develops gradually in a relationship unless you are born into it. It is hardest to see when you yourself are isolated. But it is more closely related to all kinds of abuse than anything else, with the possible exception of the use of alcohol and other drugs on an ongoing, intergenerational basis. It is hard to imagine a woman in an abusive relationship where some level of isolation has not occurred before abuse begins.

What Is Isolation?

A dramatic description of severe isolation appeared in a daily newspaper story several years ago. A man killed his wife and children. They had lived in the neighborhood for several years. Neighbors were unusually shocked because, in all that time, no one knew that a wife and children lived in the house. No child was ever seen playing outside in the yard. There were no chil-

dren's toys on the sidewalk, and no children's voices were heard. No woman was seen going to the store, or hanging out the wash, or talking to a neighbor. Neighbors saw only the husband and father as he went to and from work each day. The family was completely isolated inside the house by an abusive man. Killing his family may have been his final attempt to control them completely.

How can this happen? Why wouldn't the man's wife try to get away—to get the children out of the house? The answers to this question are speculative and based on what is known about isolation. We can't really know what was in her mind. But she apparently had no place to go; no friends or relatives to help her get away. Or if there was someone who was concerned about her, she was probably so intimidated and so isolated that she did not dare to disobey her husband by appearing outside of the house, or by contacting anyone who could help her. Her husband had probably restricted her interactions with the outside world gradually to the point where the inside of her home was the only world she knew.

Isolation can be almost complete, as it was in this story, or it can be described as existing anywhere along a scale from mild to severe. Francine described a mild level of isolation when she talked about Derek's exaggerated attention and the isolating effects it had on her, restricting her contact with other people. Later in their relationship her isolation deepened.

Most people isolate themselves some of the time from other people—even those they love the most. This is true of most people whether they live alone, or with a partner, or within a family. When it is freely chosen, some isolation can be nurturing and healing. Then it can be called "solitude." It is hard to define the exact point of severity of isolation that begins to limit the development of individuals and families, and to affect relationships in a destructive, abusive way.

It isn't likely that you will be aware of your own isolation. It happens gradually. But eventually isolation can become part of your life, governing most of what you say and do. It is easiest to

explain isolation and its effects by describing why and how it's done.

Why Does He Need to Isolate You?

For an abusive man, pulling you into isolation with him is as natural as breathing. He apparently does it without planning it or thinking about it; he does it on a subconscious, habitual level as he reacts to his own need to have you completely to himself and under his control, which is one of his primary goals. He is jealous and resentful (and frightened) of anything you do that takes your attention away from him; even when you contact members of your own family, even when you are talking on the phone to a friend, or engaging in your favorite hobby. The presence of anyone who has, or would like to have, a relationship with his wife seems to threaten his sense of security. Women told me that their abusive partners accused them of having affairs with their brothers, uncles, fathers, casual friends, the man on the street corner, the boy who delivers the groceries, a girl in a straw hat that he mistook for a man, or a person in one of the helping professions; male or female.

An abusive man's fear of not having you there with him, with your full attention on him and not on anything else, makes it seem as if you are his very soul and without you he would be lost; would almost cease to exist. His fear is the reason he monopolizes your time and attention, starting from the moment he meets you. We need to know more about the bases for his extreme fear and jealousy and possessiveness. But until we do, it is up to you to focus on recognizing these symptoms as early as possible. It may keep you from being trapped in isolation and caught in an abusive relationship.

Your partner's abusive, isolating messages are most effective when they reach you without anyone else around to offer you another viewpoint. Your partner is then free to abuse you without interference from outside of the cocoon he has created. The "cocoon of love" has now become a cocoon of control and

severe isolation. You are now more likely to accept his criticisms as the real and true description of yourself, diminishing your sense of who you are and increasing his control over you. If you should object to or rebel against the way you are being treated, your partner must try in any way he can to increase his control over you. That means greater isolation and more abuse within the relationship. This cycle of isolation escalates in much the same way as does the cycle of control. Isolation and control occur together because he isolates you in order to control you.

First, he isolates you and you rebel. Out of his fear of what you will do when you rebel, he isolates you even more, and you rebel again, driving an abusive relationship into greater isolation over time.

How Is Isolation Done?

Abusive men stop at nothing to sever relationships between their partners and anyone who tries to protect, support, advise, or contact "their" women in any way, or for any reason. Early in the relationship isolation is done with attention and possessiveness and later by fear and intimidation, and by verbal and physical attacks. An abusive man isolates his partner by restricting her contact with other people either in person or by telephone. He isolates by restricting her to the house and discouraging others from entering it; and by keeping her back from getting the professional help she needs.

Restricting Contact by Telephone

A telephone could be an important way for a woman to stay in touch with friends and family. But abusive men have many ways of restricting their partner's use of the phone even when they are not at home.

A few men attach electronic gadgets to the phone so they can listen in on the conversation. Larry put such a device on the

phone near Irene's bed. One night he heard something he didn't like during a talk Irene was having with a friend. He stormed into the room where she was talking and hung up the phone in the middle of her conversation. He grabbed her by the arms and demanded, "Why are you doing this to me?" Irene said he was upset just because she was talking to someone else—a common reaction from an abusive man.

One way Marcus stopped Eileen from using the phone was by not paying the phone bill so their service would be cut off. Another method he used was to come into the room where she was talking, "acting like he was looking for something, but he would be listening." Eileen felt so intimidated by his angry presence that she quit trying to make calls. If Marcus was especially angry or suspicious he would simply remove the phones from the house before he left for work and take them with him.

Marcus even found a way to control Eileen's use of the phone when he wasn't home, again by intimidating her. He told her she would "be in trouble" if he called her anytime during the day and heard a busy signal. Eileen took this threat seriously because she knew Marcus would find a way to carry it out. Whenever the phone rang, Eileen was filled with anxiety lest Marcus choose that moment to try and reach her. Marcus had Eileen completely cut off from using the phone as a way of making contacts with other people.

Restricting Women to the House

Abusive men often keep their partners at home by not "allowing" them to be involved in any activities outside of the house, including holding down a job or taking any kind of courses. Notice the intimidation in the examples below:

Linda said that "Tom didn't want me to work. He wanted me to stay inside the house. He didn't want me to go anywhere." Of course, Tom was free to go out whenever he pleased and he told Linda, "You better not say anything" (when *he* left the house).

Leroy told Patty that he didn't like it when she went to school. She said, "It was the first time I went to classes and stuff. I didn't go back. He told me that I was going with somebody in the school, so I just put it down."

Martha wanted to go to school, too, but her husband, Dave, never got the car to her on time. She said, "I had to stop going because I was getting [there] too late."

Every time Francine tried to take a course, Derek would seem to encourage her, but he had always had something else he wanted her to do every hour of the day. She had no time to go to classes or to study for exams. Francine said, "I was supposed to be superwoman."

This kind of not-so-subtle sabotage is a common tactic of abusive men. Francine said, "If I didn't go [out] *with* him, I wasn't supposed to go."

Another way that Marcus had of keeping Eileen from leaving the house was to disable her car and not allow her to use any of his. It was years before Eileen realized that Marcus had deliberately disabled her own car shortly after they first met. Under the guise of fixing it for her, he had done so much damage to it that she never drove it again, and she was never able to afford to buy another one. Marcus told her that it was already in such bad shape when he tried to fix it that it was hopeless. At the time, she believed him.

She said that Marcus would buy expensive cars and tell her to get behind the wheel so he could see how she looked; then would say, "Um, um, that sure is a glamorous picture you make there in that beautiful car. How does it feel?" But Eileen said she was never allowed to drive any of his cars. She was not even allowed to have the keys or to know where they were kept.

Not all abusive men are successful in keeping their partners at home. You may meet women at work and in other public places who are isolated and who are being beaten by their husbands. Wounds, bruises, and scars aren't often visible. When they are, women are good at covering them up. They may call in sick for a few days, or learn how to apply their makeup well, or

wear their clothes so that they look as attractive as possible. And isolation is even easier to hide than are the effects of physical abuse. Also invisible, of course, are the emotional scars from abuse.

Restricting Visitors from Coming to the House

Incoming telephone calls and visitors are not welcome in a home where one person is isolating and abusing another. When he is home, an abusive man is usually the one who answers both the phone and the doorbell when they ring. Then he will often try to limit contact between his partner and the caller.

Charlie had arranged the alienation of all of Annette's friends, one by one, until only her mother remained in contact with her. One day her mother and stepfather stopped by the house to see her. Charlie was home. As soon as they came and sat down in the living room, Charlie took Annette into the bedroom and shut the door. He began to talk to her about anything that came to his mind.

She said, ''We have company in the other room.''

Charlie told her, ''Just stay here with me and listen to every word I say to you.''

Annette said she was between a ''rock and a hard place.'' She was in trouble with Charlie if she went in the living room. She was in trouble with her mother if she stayed in the bedroom with Charlie. She stayed with Charlie. Her mother didn't try to visit her for a very long time after that.

Restricting Contact with the Helping Professions

The security that abusive men appear to be seeking in their relationships with a woman seems to be especially threatened by anyone in the helping professions. The story Kitty told me was typical:

Kitty had so many appointments while she was in the shelter that it was hard to schedule time to talk with her. She was

seeing a counselor, attending parenting classes, going to vocational training classes—all of the things she had tried to do at some time in her relationship with her abusive husband, Buddy. He had managed to stop Kitty from reaching help, and help from reaching Kitty, all during the ten years and six children they shared together. Whenever Kitty sought help from a social service agency for her many physical and social problems, Buddy acted insulted that they should think anything was wrong. Or he acted so righteous over the phone that he often convinced workers he was a saint for putting up with Kitty. He always told them he thought he could handle Kitty without their aid, but if he needed them, he would be sure to call. Privately he told Kitty that he despised social workers, psychiatrists, physicians, and other people who tried to help. No one from outside the house was allowed in to talk to Kitty or to Buddy. He could present one face to the outside world as a righteous, long-suffering spouse and then show a cruel, abusive face to his wife. Kitty summed it up when she said, ''He doesn't want anybody to get close to me. . . . In other words, he doesn't want me to listen to them, he wants me to listen to him.''

What Happens When Women Have No One to Talk To?

The isolation with which an abusive person surrounds you is as invisible to other people as it is to you. Your friends and relatives don't understand it, even if they do know you are being abused. They don't know how to reach in and help you. And in your isolation it is hard for you to have enough awareness of what is happening to you to reach out for help. It gets harder as you become more isolated.

Just one get-together with a close girlfriend who is able to listen to you without judging your actions could pull you out of isolation and give you the strength and courage to make another contact and then another. The more you learn about yourself from each contact you make, and each chance you have to

express yourself, the more power you will have to determine what you want to do.

One of the ways we keep in touch with ourselves is through our interactions with other people; another way is to engage in creative hobbies or interact with nature, books, art, or the circumstances of life, either alone or with other people. Your partner is trying to cut off all of your pathways to your Self. When he does that, you are a lump of clay in his hands to mold to his own needs and according to his image of you; he does not consider your needs or your image of your Self. (See Chapters 5, 6, and 11 for ways to begin to sharpen your own image of your Self.)

Women gave many reasons why they could not trust themselves or other women enough to talk about what was going on in their lives. Their mistrust, or lack of confidence, contributed to their isolation. Here are some of the reasons women gave for cutting themselves off from contact with other women:

- They were afraid of what he might think or do if he found out they had told someone else about their abusive life (and this is indeed a realistic fear).
- They didn't want to admit to anyone that they had failed by choosing the wrong man or by getting involved with an abusive man. This was a way of denying to themselves the seriousness of the abuse they were suffering. Maybe if they didn't tell anyone, it wasn't really true.
- They said that other women they knew either wouldn't know what they were talking about because they were not being abused, or that their friends *were* being abused and they did not want to burden them with stories of their own lives.
- Some women said that if they complained about their boyfriend to another woman, that other woman would be waiting to take their boyfriend away from them.
- Most of the women said they had no friends to whom they

disclosed their feelings and fears; no one they felt that close to.

Helen, who was abused psychologically by word and deed, had finally gotten the courage she needed to take a course at a nearby junior college. Unaware of the depth of her own isolation, she hadn't talked to anyone about her restricted, abusive relationship. One day in the classroom she heard another woman say something that suggested she might also be suffering from abuse. Helen asked Angela to go with her after class for a cup of coffee. Gradually, over a period of weeks and months, Helen and Angela began to open up to each other and share their stories of abuse. Thus began a long process of self-recovery for both of them as they eventually gained enough confidence to broaden their contacts with other people, separate from their abusive mates, and make productive, satisfying lives for themselves. It was also the beginning of a lifelong friendship. A close, trusting association with a friend of the same sex is vital to avoiding isolation and healing from its effects. Without it isolation deepens and loss of Self is greater.

The Later Stages of Isolation

1. First, by his using methods I have already described, including exaggerated attention, you are isolated with your abusive partner, so that there are just the two of you together.

2. The second stage of isolation, also probably automatic and unplanned, occurs when he isolates you from himself by showing a silent, cold attitude toward you at unpredictable times. Then you are truly alone.

Martha told me that she used to prepare a good meal and set the table carefully as she looked forward to seeing Dave for dinner. She wanted to talk to him; to tell him about her day and to ask him how his had gone. She wanted to plan his future with him and talk about the ambitions she still had for herself. Instead, he often came home in a cold, silent mood. Martha's

happy chatter didn't bring him out of it as she tried to ignore his silence and change his mood. Sometimes he would be brooding over a suspicion that she had been with another man. At other times she didn't know why he treated her so coldly. But Martha said that these were the loneliest times in her life. She was more lonely when she was with Dave than she was without him. Her lonely times increased as the relationship continued.

3. The third stage of isolation happens when you are cut off from ways by which you keep in touch with your Self, including your participation in hobbies or other solitary activities.

Several women told me that their partners damaged, destroyed, packed away, or hid things that belonged to them. Sometimes it was a collection on which women had spent a lot of time, like books or coins or clothes. Men took tools that women were using for their hobbies, such as drawing paper and special pencils; painting materials, like brushes and canvases; and dried flowers to be used in floral arrangements. They took the products of a woman's creativity, such as a painting or drawing. In each case the thing that was taken meant a lot to the women who owned them. Without exception they were things in which women had invested themselves; things they were proud of or to which they attached particular sentiment and meaning. Whether the men who took or destroyed these things were aware of how significant they were to the women who owned them, I am not sure. I do believe that 1) they resented losing the attention that they assumed should be theirs while women worked on their hobbies; 2) they were jealous or envious of their partner's accomplishments; and 3) they felt somehow threatened as women attempted to express themselves in a creative activity.

When you are reading a book, gardening, painting a picture, working on a collection, or doing any other kind of hobby, your attention is not on your partner. You are in contact with your Self; pulling all your faculties together. Your mind is likely to be very centered as you concentrate, totally absorbed in what you are doing. Your partner needs to find a way to stop you

from using all your energy in this way. In the process of trying to monopolize your attention and bring it back to himself, he effectively stops you from learning and growing. The effect of this third level of isolation is more loss of your Self.

This tactic sometimes backfires. Clare told me that she got angry for the first time in about five years of abuse when her partner took a drawing she had made that meant a lot to her. And Helen said that it was when her husband destroyed books she had collected, she felt a shock of realization that he could not possibly be on her side. It was the point at which both women began to separate from their husbands.

Once again, even though you need to develop a keen awareness of how you are being treated, close attention to your own reactions may encourage you to take the first step away from your relationship, as it did in the case of both Clare and Helen.

You will not be able to change how he treats you, except possibly for short periods of time. You can't assume that any change you see in him will be permanent. And how he treats you has nothing to do with how you act. He does whatever he has to do to keep you under his control, even if it means apologizing to you for the damage he has done to you and to your relationship. Indeed, if he apologizes, he does it *for the purpose* of keeping his control over you. But the next time he feels he's losing his control, the abuse will begin again.

Are You Being Isolated?

To check yourself as to whether or not you are being isolated, answer yes or no to the following questions. Use these questions to compare your life now to the way it was before you met your new boyfriend, and the way you would like it to be:

Yes No
- ☐ ☐ Does he object when you tell him you are going somewhere with a girlfriend?
- ☐ ☐ When you want to visit your parents, does he find

excuses why you should stay with him, sometimes "making" you choose between staying with him or seeing them?

- ☐ ☐ If you talk on the phone in his presence, does he object to the amount of time you are on the phone? Or does he comment on any of the things you have said, remarking perhaps that "I wouldn't have said that," or questioning you about what you mean when you make a certain comment? (Both are indications that he is listening carefully to your conversation, and trying to control what you say.)

- ☐ ☐ If you talk on the phone when he's not there, does he later ask you why the phone was busy when he called, or to whom you were talking?

- ☐ ☐ When he wants to go somewhere by himself, are you expected to stay home and make no objection—and not expect to be asked along?

- ☐ ☐ Do you ever find that he has followed you, especially if you are going to a new place with which he is unfamiliar?

- ☐ ☐ If you work or go to school, does he ever ask you, "Why do you need to work?" or "Do you really have to take that class now?" Does he encourage you in any other way to stay home?

- ☐ ☐ If you work outside of your home, or go to school, does he sometimes show up unexpectedly at the end of the day and offer to take you home, even when he has to leave work early himself to do it? Does this happen on a regular basis?

- ☐ ☐ If you are regularly going to a therapist, doctor, or any other professional person, does he find a way to object and try to restrict these visits? One thing he may do is to criticize or insult the professional person you are seeing or to accuse you of having an affair with him or her.

- ☐ ☐ When you go to the store or on another errand, does he comment on how long it took you to get back even though you were not delayed in coming home?

- ☐ ☐ If you are not home when he calls, does he ask you

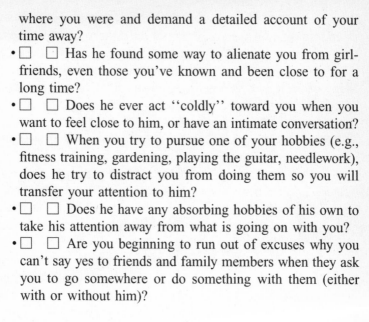

where you were and demand a detailed account of your time away?

- ☐ ☐ Has he found some way to alienate you from girlfriends, even those you've known and been close to for a long time?
- ☐ ☐ Does he ever act "coldly" toward you when you want to feel close to him, or have an intimate conversation?
- ☐ ☐ When you try to pursue one of your hobbies (e.g., fitness training, gardening, playing the guitar, needlework), does he try to distract you from doing them so you will transfer your attention to him?
- ☐ ☐ Does he have any absorbing hobbies of his own to take his attention away from what is going on with you?
- ☐ ☐ Are you beginning to run out of excuses why you can't say yes to friends and family members when they ask you to go somewhere or do something with them (either with or without him)?

If you answered yes to any one of these questions, let it be a signal to you to pay closer attention to the way you are being treated. Your contacts with other people are being restricted. You are being isolated. If you answered yes to the last question, it means you are passing up activities and people you like because you are afraid of your partner's reaction if you go out. Your choices are being limited and you are the one who is choosing to limit them. It is true that your fear of his reaction is justified. You are being put in a spot that makes your choices harder. But be aware that you are the one who is making the final choice of going or not going. There may come a time when people stop asking you to go out and do things with them.

Ask yourself this question: "Is this the way I want to live?" These are all relatively minor symptoms of things your partner may do to isolate you. The longer the relationship continues, the more severe these symptoms become. They will later be accompanied by more severe criticisms of you and any person with whom you are in contact. He will get more and more

angry when he cannot know where you are every moment; more threatened when you walk out the door to go somewhere, even when you are only going to the store. He will find cruel ways to cut you off from friends and family and from your Self. Many of these indications of isolation are based on your partner's extreme jealousy, and his fear and suspicion about your contacts with other people. His solution to his fear of other people's influence on you is to isolate you and then become more abusive in order to control you.

Your own reactions to isolation, especially early in the relationship, may surprise you. You may not be used to being treated this way; to being so closely watched and restricted. Your reactions are important. Pay attention to them and trust yourself.

As you notice even a small isolating event and your reactions to it, watch it go by and say to yourself, "That's another way he is trying to cut me off from other people" (or from him or from your Self). If you can do it without being observed by your partner, make notes in writing, including the dates, of each isolating event you experience. The more aware you become, the more information you will have on which to base your decision about this relationship.

You also need an outside source of information to validate your doubts. Again, don't hesitate to get in touch with the hotline for battered women in your community and talk about the doubts you have about the way you are being treated. They will help you understand the meaning of your observations. They can tell you when your doubts are real; tell you whether or not his behavior is abusive. And you can find out just by picking up the telephone and making a call. Call anonymously if you like. There is no need to give your name, but there is no reason not to.

It will serve no purpose for you to accuse your boyfriend of trying to isolate you. He will not understand what you mean and you will only raise his defensive anger and fear and increase the danger for yourself.

All Women Are Probably Susceptible to Being Isolated

Several years ago I saw a couple at a seminar, unrelated to domestic violence, whose story illustrates two things: 1) the abusive traits of possessiveness, jealousy, and isolation; and 2) the fact that women from all walks of life, ages, and levels of intelligence are susceptible to being isolated and therefore to being abused.

The seminar lasted for several days and was held in a remote area so that everyone there was "from somewhere else" and had not previously met. Getting acquainted and sharing information with each other was an important part of the meeting.

The instructors were puzzled by the presence of one young man whose name did not appear on the attendance lists. Each time he was asked why he was there, he said, "I'm with her," as he pointed to his female companion. He always sat next to her, pulling his chair up against hers even though there was supposed to be an aisle between the seats. He followed her closely at mealtime, talking to her the whole time and guiding her to a table where there was only room for two people. Everyone else intermingled and used the time to get better acquainted and learn from each other.

One day I happened to be in the lunch line behind this girl. I said hello and asked her where she had come from. She looked as if she was about to speak to me when her boyfriend took her by the arm and pulled her over to their table for two. As far as I know, no one else had any greater success than I did trying to get acquainted with her.

This young woman was a smart, professional person in her job but she was so intimidated by her boyfriend that I could guess she had already been threatened and was forced into obedience by her fear, and also possibly by her love, hope, and fascination. Don't let yourself get caught like this.

Even though it is possible for any woman to become isolated and fall into the trap of an abusive relationship, women who

have lived in isolated families appear to be more susceptible to it. They have been accustomed to limited contact with other people, and are likely to feel more familiar and comfortable with the isolation a new partner imposes on them in the beginning, and slide into it more easily.

Isolation serves the needs and purposes of an abusive person. It's the basic material from which the spider weaves his web.

CHAPTER 3

Dr. Jekyll and Mr. Hyde

Robert Louis Stevenson, in his book *Dr. Jekyll and Mr. Hyde,* described the actions of the cruel Mr. Hyde: "And then all of a sudden he broke out in a great flame of anger, stamping with his foot, brandishing the cane, and carrying on . . . like a madman." This description is strikingly similar to the words used by abused women to describe their partners when they become suddenly enraged.

Every abused woman I talked with, freely reported that her abusive partner was a "Dr. Jekyll and Mr. Hyde." They immediately understood the meaning of the phrase before it was described to them. They had all lived with it.

Eileen was among the many women who described the unpredictable nature of her relationship. I first met her late one night in the dining room of a shelter. Other women who were still sitting around the table talking, joined in our conversation. They said that they never knew what kind of mood their husbands would be in. Eileen agreed and described the feeling she had when she heard the crunch of gravel beneath the tires of her husband's car as he pulled into the driveway in the evening after work. She said she held her breath as she waited for the car door to slam; that her tension increased with every footstep she

heard as Marcus made his way to the door. As Eileen talked about her fear of Marcus, she looked like a little girl watching a horror film. She said it didn't matter whether Marcus came home in a good mood or not. Even when he treated her well she began to anticipate the worst. She said, "This nasty taste and tension would fill my body from my feet to the top of my head. . . . It would all be stress." She said that not knowing what to expect from Marcus kept her in a chronic state of tension and anxiety. She didn't know whether Marcus was going to greet her with a kiss or come in yelling and cursing, complaining about what she had made for dinner.

The other women sat nodding in agreement as Eileen told her story. They agreed that their partners were "good actors," that they could act the part of a really nice guy in front of their friends and relatives and then viciously turn on them when they were alone. When the "good guy" appeared and he treated her well, it gave her hope for the future of their relationship. When the "good guy" went away and she was treated badly again, she was confused.

This good acting is the reason that many friends, family members, and people in the helping professions often believe what the abusive man tells them instead of what an abused woman says about the way she is being treated.

Barbara was a nice-looking woman, intelligent and well spoken. She had cultivated friends in a twelve-step program in spite of her husband's attempts to isolate her. The fact that there was nothing about her that might cause anyone to doubt her word makes the rest of her story even more startling. Barbara was dismayed to find that her husband George's psychiatrist believed George's story but did not believe her when she tried to tell him about George's abusive behavior.

Barbara had been verbally abused for over twenty years and physically abused and threatened for several years before she decided to try to find someone who could help her. She went to a center in her town that advocated for victims of violence. Her

voice still trembled with emotion several years later as she told me the story.

Barbara described George's abusive treatment of her to the counselor at the victim center. The counselor believed what Barbara told her. As a result of this meeting, George was eventually ordered by the court into a psychiatric hospital for an evaluation.

In her own meetings with the psychiatrist Barbara described George's constant, cruel verbal abuse and how he had begun to hit her in recent years. George was apparently able to act the part of a model husband. He convinced the psychiatrist that the really serious problem was his wife, who, as the psychiatrist could see, was distraught most of the time—even hysterical. The less the psychiatrist believed her, the more distraught Barbara became. The psychiatrist decided George was completely normal and was ready to release him from the hospital.

Then Barbara remembered the audiotapes she had made with a recorder she kept under her couch in her living room. She took them to the psychiatrist. He changed his diagnosis when he heard George's unending stream of insults, insane accusations, wild cursing, sarcasm, yelling, and threats.

The psychiatrist prescribed medication that calmed George down for as long as he would agree to take it. Barbara said, "When they heard that tape, they really knew what I was talking about. But not until then." The medication George took kept Barbara safer for a while and made for a more peaceful homelife, but did not help to restore the relationship they had shared in earlier years.

The acting skill of an abusive man—the ability to convince everyone he is kind Dr. Jekyll—interlocks with a lack of support from professionals to discourage women from seeking help. It effectively shuts them up and keeps them from talking. It adds to their isolation, which is already a formidable barrier to getting the help they need.

So, when you try to tell other people how your partner is hurting you, he may be such a good actor that no one will

believe you. Don't be surprised when this happens. But don't give up trying to find someone who will believe you. Otherwise, you'll be more cut off from other people than ever before. Of course, when you call the hotline, you will be believed.

At first you may see your new boyfriend only as the kinder, more composed Dr. Jekyll. When Mr. Hyde appears, it is usually in the form of a surprising, sudden angry outburst. You can't prepare for his appearance because you don't know when the change will occur, or what will trigger it.

The suddenness with which their partners can change is startling and confusing to women who are being abused. Martha said that sometimes she thought she had it made because everything was going so well. "I remember he was laughing . . . and then all of a sudden, Boom! It was like right in a flash and he had me slammed up against the wall again."

There are several ways that abused women said they tried to defend themselves. One way was to maintain a state of tension and anxiety as Eileen had done—trying to prepare themselves for the next outburst whenever it should come. Another was to try to anticipate what would make him angry and "fix" it so he could not become angry. The truth is that neither of these methods is successful, and I don't recommend them. When you maintain a state of anxious vigilance, trying to be ready for anything that can happen, it will take a toll on your physical and mental health. If you try to fix whatever you believe will make your partner angry, it is easy for him to find another target for his anger. You will not have changed his behavior. I never heard of any woman who was successful in stopping the angry outbursts of a Mr. Hyde.

Living your life is getting more dangerous, but you are beginning to deny that now. At this stage in your relationship you may begin to express your own anger. Some women get angry and some do not; some fight back both physically and verbally and others do not. Some of your other reactions may include depression, fear, retaliation, confusion, anxiety, and of course the emotional pain that comes from being hurt by someone you

love. Your greatest weapon against a deepening loss of your Self is to be aware of what your reaction is; without judging it or trying to control it or change it.

Your partner may have a volatile temper, and be prone to sudden outbursts of anger; but you may not see that yet. He may also be a heavy drinker or even alcoholic (sudden mood swings commonly go with the use of alcohol and other drugs), but disguise that from you by not using much alcohol or other drugs in your presence.

Within your isolation how do you recognize what is really happening to you? And what can you do about it?

First decide whether you are living with a Jekyll and Hyde personality. Check the following questions with a yes or no.

Yes No
- ☐ ☐ Does your boyfriend/husband treat you more kindly when the two of you are with other people, sometimes even bragging about you to them?
- ☐ ☐ Do people act surprised (to the point of not believing you) if you try to tell them he is sometimes abusive? Is this true even with your own mother? (It's almost always true with his mother.)
- ☐ ☐ Are the changes you see in him sometimes very sudden? Can he be laughing or making love to you and then in the next few minutes change into someone who is throwing you up against the wall or growling questions at you and accusing you of making love to his best friend behind his back?
- ☐ ☐ Are you sometimes startled by him as he comes around a corner and you meet someone you feel you hardly know?
- ☐ ☐ Do you wait for him to come home after work, tensing up when you hear the car door slam shut in the driveway, wondering what he will be like when he walks in the door?

• ☐ ☐ Have you ever called him at work to try to find out
what his mood was like before he left work to come home?
• ☐ ☐ By the time he got home had his mood changed?

If you answered yes to any of these questions you are living
with someone whose behavior is unpredictable. Some likely
effects:

1. Your isolation will deepen because you are less likely to
talk to people about the abusive life you are leading when you
know they will believe not you, but your partner. *This is how
isolation and Jekyll and Hyde behavior lock together to im-
prison you.*
2. In order to try to protect yourself, you tend to focus your
attention more and more on your partner; trying to predict what
he will do, so you will know what to do yourself to avoid
confrontations and keep him (you believe) from getting angry.
3. Because you are focused on your partner you are:

• not taking care of yourself, and
• you are convinced you can change him if you keep trying
 harder, and
• you try harder to "be good," obey his commands, and
 please him, and
• you are more likely to believe him when he tells you that
 you are somehow at fault for the abusive treatment he ad-
 ministers at unpredictable times, and you are
• devastated as you accept the blame and responsibility for
 the violence in your relationship.

There is no one around who can tell you that nothing you can
do will stop his angry outbursts. And he himself keeps insisting
that if you would only do this or that, he wouldn't act the way
he does. You become convinced that you just haven't learned to
be perfect enough yet, but when you do, everything will be all
right; that a change in you is enough to change him perma-

nently back to kind Dr. Jekyll. This belief, that the abuse is somehow your fault, may be your single most difficult obstacle.

I learned there is really no way to predict when an abusive man will make his first threat. It may come as you see your partner turn into Mr. Hyde for the first time. He often makes his first threat at a time when he feels pressured by his fear that you may leave him, even temporarily. His threat can range from mild intimidation to a promise that he will kill you or one of your family. This first threat can come early in the relationship, or after a year or two. Once it occurs, and you realize he is capable of carrying it out, you are locked more tightly than ever in your relationship with him. Now fear takes the place of any hope you may have had. Now, more than ever, you need help to get away, if that is what you want to do. It is much easier to get away if you make a decision to end your relationship before this first threat is made.

If you believe that you are already locked in an abusive relationship, use these first three chapters to identify how you became isolated and how you were caught. When you can map your path into a relationship, it may be easier for you to begin to plan a way out of it. You can, of course, also use your new knowledge to avoid the next abusive relationship.

I hope you've now reached a point, in reading this book, when you are beginning to wonder how a stranger can know so much about what your life is like. The answer is simple: Many women are leading lives similar to yours. They react in similar ways to similar patterns of abuse. And many of them still think they are alone. The solution to your despair is to reach out for help. See Chapters 7 and 8 for details on how to do that.

Take the time now to visualize just one other woman who is living with an abusive partner. See her clearly and picture exactly what she looks like. Imagine that she is being yelled at, beaten, and threatened and doesn't know what to do, and she is trying to get in touch with you to ask your advice. If you could meet her in person and the two of you could talk together, what

would you say? Would you tell her to keep on living the way she is living now? Would you tell her there is hope that her partner will change and become the loving, attentive man she thought she was marrying? Would you tell her she is safe and that her children are in no danger from her partner? Would you tell her that the abuse she endures is her own fault?

What would you tell yourself?

The Form of the Relationship: Interlocking Actions and Reactions

As the relationship between any two people develops, their interactions form a pattern that is independent of either one of them. In an abusive relationship, one where isolation is closing off interaction with other people, the pattern of the relationship becomes rigid and inflexible, because little new information is allowed to come into the relationship from other people who are outside of it (Sieburg, 1985). The interactions listed below show the form of an abusive relationship:

His Actions (Abusive Control)

- His exaggerated attention

- His possessiveness/ jealousy
- His criticisms/accusations other verbal abuses

Your Reactions (Defense)

- You enter "cocoon of love"/early isolation
- You assume he cares for you
- Your explanations/ apologies and efforts to please

- He competes for attention from others
- His denial of his abuses
- Possessiveness and jealousy worsen; he hovers, watches you
- He restricts contacts and activities
- He defines you (name calling/insults)
- Isolation hardens; blames/accuses/criticizes

- He threatens/intimidates you/family
- He begins to isolate you from himself; cold/silent/unpredictable
- Cuts you off from paths to your Self
- Denies/justifies abuses

- You don't realize "he is not on your side"
- Your denial of his abuses
- You begin to have doubts. You begin to pull away, but
- You have fewer contacts; talk less
- You begin to accept his definition of you
- You try harder to please him so he will change (be calmer, safer)
- You are afraid/controlled

- You are alone!

- A turning point for you? (Anger, shock?)
- May minimize danger/damage/isolation

And as your relationship continues, it often hardens into even more abusive patterns:

- He alternates nice with cruel actions; a good actor
- Physical abuse begins/verbal abuse escalates
- Sexual abuse often added

- Your silence/isolation from others worsen
- You are more reactive toward him
- At the same time: you show strength, rebellion, and courage, even when you are scared, hurt, or humiliated

- Terrorism may begin
 (using a weapon or
 destroying favorite pet/
 possession)
- He justifies his actions

- You accept blame for
 abuse

The signs he shows as the relationship continues are more obviously abusive. The signs you show are your increasingly defensive reactions to his isolation and abuse. As his isolation and abuse of you continue, your defensive reactions increase in their intensity as well; he in turn increases his efforts to control you.

You will probably experience the rest of this pattern even if you never experience physical blows or sexual abuse.

The fact that these patterns are rigid and inflexible is important to you in the following ways:

1. When you are isolated together, interactions like those described above become interlocked (when he says certain kinds of things to you, you tend to react in ways that are similar to the way you reacted the last time) and therefore become more resistant to change.

2. If you try to improve the relationship by changing what you say and do, your partner will likely increase his efforts to control you. He needs to bring your behavior back in line with the pattern that has been formed, and he will do anything he can to make that happen.

3. When you think about returning to an abusive partner once you have left, remember that this abusive pattern is likely to be still waiting for you. It is likely to be resumed if you return to him, regardless of what promises or apologies your partner has made to you.

Even when a physically abusive person can learn to stop hitting or otherwise learn to manage anger, patterns of verbal

abuse are likely to remain, especially the tendency to make verbal threats (Caesar and Hamberger, 1989). Of course, verbal intimidations are a strong sign that the need to control you is still there; that your partner is still abusive, even if the hitting has stopped.

If your partner receives training or counseling to change his patterns of abuse, call the battered women's hotline in your community and talk to an advocate before you decide to accept him back into your home or your relationship. See Chapters 7 and 8 and read about how you can know whom to trust and what kind of help you can expect to find when you call a hotline.

I'm not saying it's impossible for an abusive person to change. But I am saying that it is never safe for you to count on it. It can be dangerous for you to assume that your partner can be permanently changed into a nonabusive person. As in Stevenson's story, it becomes more and more difficult for cruel Mr. Hyde to return to the kinder personality of Dr. Jekyll.

IT'S UP TO YOU TO DECIDE WHAT YOU WANT. HOW DO YOU DO THAT?

Take a Closer Look

Phyllis had experienced all of the stages of abusive isolation I have described in the first three chapters. Her husband of many years had cut her off from contact with other people, from himself, and finally from ways of keeping in touch with her Self. She had never been physically abused, but she had been profoundly hurt by years of cruel words and actions, and she was still affected by the loss of her Self even though she was divorced from her husband. She looked for a way to reconstruct her life. Her ex-husband was an alcoholic and one day she decided to call the Al-Anon number in the phone book to find out where she could find a meeting she could attend. Al-Anon family groups exist to help anyone who lives with, or loves, an alcoholic. Phyllis was surprised to find a meeting only a few blocks from her home. I talked with her after she had been attending meetings for about a year. As she told me about the steps of her recovery, she described the relationship that had damaged her.

Phyllis said that she felt as if she were a stone statue, and her abusive husband were her sculptor. She said he had figuratively, with his constant fault-finding and other verbal abuse, chipped away at her with his mallet and chisel after she thought she was

already a completed work of art. She said she didn't know how to recover the lost pieces; how to repair herself, or how to keep her husband from destroying her, little by little. She said she felt her heart had been shattered into small pieces. She knew she was a distorted and diminished form of the person she had been before she was reshaped in her husband's hands. Phyllis learned how to let her resentments go and began to understand how many people suffer in the same way she had. When she could let go of the past she was able to concentrate on the present and she began, piece by piece, to make herself whole again.

Whether you have experienced physical or verbal abuse or both, you can't always be aware of the extent of your own loss of Self while you are still living the experience. Even when your partner is no longer present, you are living the experience in many ways unless you change your habits of reaction. Al-Anon groups, groups for battered women, private or agency counseling, can help you do that. You don't have to do it alone.

To say that "your self-esteem is low" is a weak and inadequate description of the loss of Self you have experienced. The Self, as I am using the term, is the complex central core of your inner world: your temperament, consciousness, thoughts, ideas, beliefs, perceptions, and values. It develops from birth and gels as years pass. It is buffeted and shaped as you interact with other people, the natural world, and the circumstances of your life. Your Self is both the basis you use for interpreting your world and the sum of those interpretations. Your Self is at your very center, and an important part of it remains unchanged throughout your life—the part you think of as "me." It affects how you think and the choices you make in your life. It takes more than cheerleading to rebuild and recover your lost or forgotten Self.

But you can retrace your steps and begin to recover that Self, piece by piece, as Phyllis eventually did. Don't focus on the state of your self-esteem right now. Of course it is at rock bottom if you are now living, or have lived, with an abusive person.

One of the most important signs of the loss of Self is the loss of your ability to know what you want for yourself. It takes

many women a little time, and help from other people, before they can remember or decide what they want. The step that comes before that, even though it may seem like a negative approach, is to decide what you *do not* want for yourself. You can do that by taking a look at your life in several different ways and asking some hard questions each time.

Take a Look Backward

Normally, it's a good idea to stay out of the past because the only thing you can change about your past is how you feel about it (that's quite a lot, by the way). In this case, however, there may be a lot you can learn from looking over your shoulder. To help you look back, check yes or no to the following questions:

Yes No

- ☐ ☐ Has my relationship changed since the beginning? Is it different than I'd hoped it would be? Than I'd expected it to be? (This can be true in happy marriages as well—just continue to answer the other questions.)
- ☐ ☐ Is my partner different from what I'd thought he would be? Is he more unpredictable, more harsh and less attentive, less tender and sentimental, more abusive?
- ☐ ☐ Am I staying with him because I still hope he will change back to the man I first met and was attracted to?
- ☐ ☐ Have I changed since the beginning of my relationship with him? Have I become more reactive, more angry, more tense, more pressured and stressed?
- ☐ ☐ Am I losing more energy all of the time? Is it harder for me to get things done?
- ☐ ☐ Have I become more isolated from my family and friends? Do I see them less often than I used to?
- ☐ ☐ Do I still believe I can change him back into what (I thought) he was if I just learn how to say and do exactly the right things (according to him)?

A yes answer to any of these questions is a signal that warns you that you are hanging on to a hope that is probably not realistic, and that you are suffering for it. A yes answer to the last question reveals that you are on the long slide into a loss of your Self; the person you are and the person you want to be. It also means that you are taking on the full responsibility for making the relationship work; that you accept the blame for the abusive actions of your partner; that you believe that if you can just act differently, everything will be all right. Has anything you have done up until now made any difference? What about how he acts?

Then, Take a Look in the Mirror

First take a careful look at your answers to the first questions and then look in the mirror and ask yourself a few more questions, just as Francine did after she had been beaten and threatened with a knife, the day before she decided to go into a shelter for battered women. It was these questions that made her decide she didn't want any more abuse or brutality or terrorism to be a part of her life. But please don't wait until you've been hurt before you ask yourself these questions:

Yes No
- ☐ ☐ Is that really me living in this situation? (If trying to answer yes or no to this question bothers you, don't worry about it, just do the best you can.)
- ☐ ☐ Is what I am becoming different from what I want to be?
- ☐ ☐ Am I spending so much of my time and attention trying to change him so I can stay with him, that I am ignoring who I want to be and what I want to do?

A yes answer tells you that it's hard for you to reconcile the person you are now, living the life you are living, with the person you were, or thought you would be.

Take a Look at Your Children

The next place to look may be the toughest of all to do, but for your sake and theirs, take a look at your children and ask yourself:

Yes No
- ☐ ☐ Is he critical or cruel with them as he is with me?
- ☐ ☐ Are they beginning to yell a lot, point fingers of blame at each other, or cry or sit too quietly in the corner much of the time?
- ☐ ☐ Are any of my older children (from about eight on up) beginning to blame me for the abusive actions of my partner?
- ☐ ☐ Are any of them beginning to act like my abusive partner?
- ☐ ☐ Are they angry with me for not stopping the abuse done to me or to them?
- ☐ ☐ Am I tense and tired all the time; getting farther and farther away from being the mother I want to be? Sometimes even abusing my children myself?

If you are answering yes to any of these questions, your answers need not make you sad. If you want to, you can rejoice that a little bit of the veil of denial is beginning to lift from your mind and from your soul. You may be at the beginning of changes in yourself that can also bring positive changes to the lives of your children.

Take a Look at Your Self

Take a look at how you are losing your Self. Answer the following questions to begin to understand how your Self is slipping away.

Yes No

- ☐ ☐ Think about the way you spend your time during the day. Do you spend most of the day doing things for other people or thinking about what you will do to please other people? Or even what you will do just to try to keep them from getting angry at you?

- ☐ ☐ Have you stopped trying to voice your opinion about almost anything, knowing that what you say will be discounted or lead to your being insulted?

- ☐ ☐ Try to make a mental list of things you love to do. Do you have a hard time listing ten things? Even five things? Even one?

- ☐ ☐ Has it been a long time since you have gone somewhere or done something that you chose to do? Is it hard for you to even think of a place you would like to go?

- ☐ ☐ Did you used to have some kind of creative hobby, but now have given it up or just do it mechanically without thinking about it or putting your own creative ideas into what you are doing?

- ☐ ☐ Is one of the reasons you have given up your creative activities because they get in the way of doing something to please your partner; or even because your accomplishment annoys your partner in some way?

- ☐ ☐ Have you lost track of how to describe who you are (not what you do, but who you are)?

- ☐ ☐ Are you beginning to describe yourself only as your husband's wife, your children's mother, or your parents' daughter?

A yes answer to any of these questions tells you that your Self is in fragile condition and needs to be nourished. The only person you can count on to do that is you.

Take a Look at Your Loneliness

There are different kinds of loneliness. Many women de-scribed "a hole-in-the-gut" kind of empty loneliness they felt sometimes as they were growing up and into young adulthood until the time when they met their abusive partner. When they first met him, they often thought they had found a way to fill up the space that had been empty for so long.

Then, as they lived with an abusive person, they began to experience the kind of loneliness that comes from not having anyone with whom to share the secrets, the joy and sadness, of life; from being too daunted by their partner's unpredictable growing aloofness and coldness to be able to express them-selves fully.

As his coldness grew and his criticisms and put-downs never seemed to end, women talked about the greatest loneliness of all, when they realized they were more lonely in their partner's company than when alone or with someone else. It was when they were alone, or doing something outside of their homes, that they had their only feelings of peace, success, or accom-plishment; that they were able to regain some measure of the strong Self they remembered.

Look back over your relationship with your partner and an-swer the following questions:

Yes No
- ☐ ☐ When you first met him did you ever think: "This is great. I'll never be lonely again"?
- ☐ ☐ As he became colder toward you did you feel lonely, having no one to feel close to, to talk intimately with?
- ☐ ☐ Did you ever feel envious when one of your friends said, "My husband is my own best friend"?
- ☐ ☐ Then as you became more isolated from other peo-ple and he began to insult you and put you down, did you

begin to feel your greatest loneliness when the two of you were together, rather than when you were alone?

If you answered yes to any of these questions, you are indicating that you are cut off from other people, from your partner, and from your Self as well. You are also saying that "not only does my partner fail to fill my needs for a fulfilling relationship, but the way he acts toward me increases my feelings of loneliness." Many women said there was no lonelier feeling in the world than waiting for a husband to come home, looking forward to spending some time with him, and then having their expectations dashed by his harsh words or cold attitude, or possibly a blow from his fist. Be aware that much of your loneliness now comes from the gap between what you expected a "close" relationship was like and the reality of what you experience as you live with an abusive partner.

You are also cut off from the awareness that you alone have the power to plug yourself back into the world from which you have become disconnected in your isolated relationship with an abusive person. Be aware of your power to change your own life.

Take a Look at the Form of the Relationship You Are In

Many abused women described their partners as weak, wimpy men. They said this even while admitting that their partners often looked and acted very masculine. They said their partners had often had domineering mothers, and were men who had been their mothers' favorite sons. They described them as people who carried an attitude that "they could do no wrong." This is the kind of person who can apparently justify anything he does, including beating his wife.

You ride a roller coaster from the high of recurring hope down to the depths of abusive words or actions and back up again. The highs don't last very long and the depths get deeper

with each descent. Nothing you have done has made any difference. You expect more and more of yourself and less and less of him. You are even expecting to be able to keep peace in the family and then you blame yourself when you can't. What little you do expect from him is seldom, if ever, fulfilled. Instead of more appreciation from him, you are getting less. When you accomplish something, he puts you down instead of rejoicing with you. If you are finally able to earn some money, he perhaps tells you that you are the cause of his paying more taxes.

You are in a relationship where your partner needs to feed on your strength, your spirit, your Self, because he needs it for himself; he doesn't have much energy or strength of spirit or Self of his own. After you are caught in the web and inoculated with the paralyzing poison of exaggerated, possessive attention, and after you are isolated, he begins to drain you of vital life spirit he needs to nourish himself. When you have refilled your Self on his apologies after he has hurt you, his tension begins to rebuild, and he will eventually drain you again. But you have the power to break out of your isolation, reconnect with other people and with your Self, find ways to nourish your mind, your body, and your spirit, and remain whole.

Observe his actions and your reactions in the summary at the end of Chapter 3 and see the form of the interactions between you. This relationship is not one of mutual love, trust, respect— or mutual anything. It is one in which your partner is desperate to keep the upper hand. He needs to maintain complete control over you and everything you do, say, and think. His survival depends on it. It is not a give-and-take situation; it is not a fifty-fifty cooperative relationship. He gets the freedom and control and you get the abuse and the blame. It is the relationship of the spider to the fly. The spider is in control once the fly has innocently touched his web, and you did that when you first met him and understandably fell under the spell of his charm and attention.

This kind of relationship does not magically turn into one of which many women dream; a relationship where he is on your

side, where he can share your sorrows and joys and you can share his; where you can relax and really look forward to the time you see him in the evenings and on weekends.

Take a Look at Your Strength

Take a look at your strength and how you have been using it. Most women who are being abused are very strong women, and they describe themselves that way. They are generally not weak and helpless. To begin to understand just how strong you are, look at what you have already survived.

Sometimes, however, your strength may work against you. Abused women have often been observed to use their strength to stay with their abusive partner and to maintain the relationship.

Women in our society are taught to believe that it is their duty to stay with the man they have chosen, no matter what happens. Their parents often believe it too. When a daughter wants to leave an abusive man, they don't often back her up. A woman who seeks refuge at her parents' house is often told by one or both that it is her duty to go back to her abuser. And it doesn't matter if she shows up on their porch with her face and body cut, bloody, and bruised, she is still expected to return to the man who hurt her.

Opal, one of the women I met in a shelter, told me that her mother had taught her a sense of loyalty. She was proud of being a strong woman and she felt that her loyalty to her abusive partner was part of her strength. When Opal sought refuge in her father's house after she was beaten, he told her to go back home to her abusive partner. He said, ''You made your bed hard, now you have to lie in it.'' Other women reported hearing similar words from their mothers or their fathers. See Chapter 5 for other examples of how women sometimes use their strength in self-defeating ways.

To find out how you might be misusing your strength, take a look at the following questions:

Yes No

- ☐ ☐ Have you always known you were strong, for as long as you can remember?
- ☐ ☐ Have you ever felt proud of your ability to stay with a difficult situation?
- ☐ ☐ Do you think it is your duty to stay in a difficult situation?
- ☐ ☐ Have you had the experience as a young person of having to make the most of a bad situation, maybe even an abusive one?
- ☐ ☐ Are you using your strength and determination to "stick it out" in the abusive relationship you are in because you think you should?
- ☐ ☐ Would you feel disloyal to your abusive partner if you left?

A yes answer to any of these questions means that the way you have been using your strength can be contributing to your loss of Self instead of working in your favor to keep you safe and whole.

After you have looked carefully at each of the things I have listed in this chapter, keep them in mind as you begin to decide for yourself how you *do* want your life to be. It is important to understand that you are not merely a straw being tossed on a breeze of circumstance. There is more to you than that. You have the power to make other choices, little ones and big ones. A seemingly small choice like making a phone call to the hot-line for abused women can open up a lot of other choices that you perhaps have not known you had.

Most women who live in our society have been taught that they are the ones who nourish and care for others, and that the quality of any of their life relationships is their responsibility. Women hear these messages from an early age and from every corner of their lives: from family members, from religious leaders, and from society at large. Seldom are they taught that they need to care for themselves first in order to preserve the physi-

cal energy and the quality of Self they need so they can experience the life they deserve. Women (and men) need a strong, healthy Self in order to decide what it is that they want to do; what they want to accomplish; how and what they choose to contribute to the world.

There are many ways you can make a contribution to the world and be "selfish" enough to take care of yourself at the same time. To lock yourself into a position of servitude is not your only choice. When you have learned to freely choose your own way of serving the world, what you do for others will automatically be good for you too; will nourish your spirit at the same time, with the same motions, as it feeds other people.

I hope you will gradually learn that it is all right, and not an act of selfishness on your part, to take care of yourself first; that everything else you do or want to do rests on being as physically, mentally, emotionally, and spiritually fit as possible. Do you call it selfish to put taking care of yourself at the top of your list of things to do? Would you feel guilty if you did that? Think about it. If you don't take care of yourself, who else is going to do it?

If you are in danger of being physically hurt right now, call 911 or the police immediately. You will be given help appropriate to your circumstances. If you have a little more time, you can look in the appendix to find possible headings for the battered women's hotline phone number in your area. Look it up, call it, and talk to the person who answers about your safety and about your choices; or call the national hotline.

Physical safety always comes first. If you truly believe you are safe now, but you haven't decided what to do yet, keep on reading.

It's Time to Use Your Strength in a New Way

You have taken a good look at what you don't want. Now it's time to discover what you *do* want.

The suggestions in this chapter and the next are made with the following assumptions: 1) that you are invisibly isolated with an abusive partner; 2) that you may have few, if any, supportive friends or relatives to talk with on a regular basis; 3) that you have no other resources at hand or don't know where to begin to look for them; and 4) that you need some way to "pull yourself up by your own bootstraps." In order to be able to do that it is necessary that you begin such active steps as you can safely take while still under the watchful eye of your abusive partner. The activities in this chapter have been selected because you can perform them by yourself, increase your levels of awareness about your life, and begin to increase the energy and resolve you need to carry out new decisions.

To begin your own rediscovery, first read the list of suggestions in this chapter and the next. Then, at your own speed, as long as you are safe, go through each one. If you are not safe, put everything else aside, call 911, the police, or the hotline for battered women, and get some help.

Be aware that if your partner sees you growing stronger, he

may increase his efforts to pull you back down. Don't put yourself in danger while you are working on these ideas. Find a safe, private place to spend time with yourself.

Self-Talk: Replacing His Descriptions of You with Your Own

One of the primary ways you are losing your Self is, quite understandably, by believing what your abusive partner is telling you about yourself. When there is no one else around to counteract what he tells you, you hear only his criticisms, his insults, and his definitions of who you are. You hear only that you should be grateful to him for putting up with you because (he says) you couldn't possibly find anyone else who would. This is devastating talk! And it's very hard to fight, because:

1. You are in deep isolation with your partner—his abusive messages are the only ones you hear.

2. Women in all cultures have been told for centuries that they are fundamentally inferior to men (Branden, 1994). This put-down by society doesn't support women in their search for a healthy self-concept.

3. Your abusive partner may be able to flood you with negative messages about yourself more quickly and strongly than you can furnish the positive messages for yourself.

For example, Barbara was faced with such a stream of abusive talk from the moment her husband walked in the door in the evening after work that she didn't have a chance to respond to him. And no matter what she said, it was the wrong thing. If she remained silent, George eventually ran out of words and quieted down. If she said anything at all, he used her comments to begin all over again with sarcasm, accusations, insults, and put-downs. Barbara was forced to choose silence. But if she hadn't developed a circle of supportive friends to whom she could talk about her abusive homelife, and been able to express

herself in other ways, she would have experienced a profound sense of loss of her Self.

4. Negative messages are very hard to fight, especially if you were a young child when you began to hear them, and you heard them fairly often, or

5. if, as a child, you heard the same negative messages you are hearing now from an abusive partner and you don't know much about what positive messages are, or

6. if someone you considered to be important in your life, such as a parent or a teacher, was the one from whom you heard negative messages as a child.

All of these conditions make negative messages harder to get rid of. See Helmstetter (1989) for much more information than I can possibly give you here about self-talk and how to counteract other people's negative messages. He suggests two important ideas:

1. Eliminate your own negative messages by listening to the way you talk to yourself now, and gradually getting rid of those messages.

Are you saying to yourself, "I'll never be able to get my life together," "I don't know where to start," "Nothing ever goes right for me," "I can't live without him" (can you live with him?), "I'm never able to do anything right," "If I didn't____ _____[fill in your own words of self-blame], this relationship would be all right"?

2. Don't wait for your old, weakening messages to go away—you may never get rid of them, especially when some may come to you from as long ago as your childhood.

Until you can begin to establish meaningful contact with other, supportive people, your only choice is to begin to tell yourself what you need others to tell you, to tell yourself whatever you need to hear. Start with the list of truths below, and when you begin to get the idea, make up your own positive messages about yourself and write them down wherever you

think it is safe to do so. There is no limit to the number of messages you can list.

- "He is hurting me and it is not my fault; it's his."
- "There is *no* excuse for anyone to hurt me this way."
- "I have a right to a relationship with someone who cares about what happens to me—all of the time. I deserve it."
- "Anyone who hits me, yells at me, insults me, blames me, criticizes me, threatens me, or treats me like a competitor instead of a partner is not on my side."
- "The man who is hurting me is only interested in controlling me and keeping me with him." Ask yourself: "Is this love?"

And most important:

- "He is not going to change. I will stop my efforts to change him, and turn my strength toward finding the help and energy I need to make my life into what I want it to be."

With this last statement, "He is not going to change," goes the idea that you can now let go of using your strength to stay with an abusive person, and begin to use it to create the life you want and deserve.

And then create messages about yourself like:

- I can do anything I set my mind to.
- I can learn anything I need to know including self-confidence.
- I am a valuable person.

Now fill in more of your own messages and follow the guidelines below.

Memorize your new messages if you can and repeat them to yourself whenever you have time. Remember that new mes-

sages you give yourself will be filtered through the old ones you have in your mind. Just begin to make your new messages to yourself strong enough to be heard above your old ones and the ones you are getting from your partner. Your messages need to be stronger than his, and to be brought to mind as frequently as possible. You have more control over your messages to yourself than you think you do. You can add strength to your new messages in the following ways:

- Be very specific when you write your messages down, or memorize them. Give your mind detailed instructions about how you want yourself described and defined. Use your imagination and make it good. Use the most positive adjectives you can think of to describe yourself, like *capable, confident, caring, smart, ambitious,* and *valuable.* It doesn't matter if you don't wholeheartedly believe all of these right now. Of course you don't. You've been told otherwise for a long time. Just try it anyway. Add all the "I can" messages you can think of like, "I can make my dreams come true," "I can find out where to start," and "I can heal my wounds and make myself whole again." When you hear negative messages from anyone else that don't fit with your own positive ones, tell yourself, "That's not true, it doesn't fit."
- Repetition strengthens what you tell yourself. Repeat your messages many times a day every day for at least four weeks before you expect to notice a change in the way you think about yourself. And then keep at it.
- Remember that your message will be stronger if you value the source of the message. The source of your message now is *you.* So make sure you consider yourself the most important and accurate source of information about yourself. You are the expert on yourself. No one else can come closer to finding or knowing the real you.
- The more emotion you can attach to your new messages, the faster and better they will stick with you. For example,

if you are entirely sure you are alone in the house, you can make yourself comfortable in front of a mirror and dramatize your messages any way you can think of. You can shout, whisper, make faces as you talk, or use different voices to get your message across.

You can repeat your new messages to yourself even when you are cooking dinner, reading the paper, and doing the laundry. Try it even when your partner is standing before you (or over you) trying to tell you his ideas about who you are and what you should say and think and do. Watch him as he delivers his diatribe against you and know in your heart that he doesn't know what he is talking about.

Be patient with yourself. You've heard negative messages from other people for a long while. Changing that may take a little time, but you will be surprised at how quickly you learn that you might have some control and power over your life after all.

Keep a close watch on yourself. If you find you're writing down negative messages about yourself, switch to positive messages and then work on them until they become even more positive and more certain.

• Another way to get your self-talk messages through to yourself is to record them on an audiotape, put them in a Walkman that you carry with you. Then play them in your ear everywhere you go as long as you are alone.

3. Another powerful way to talk to yourself and get to know the real you is to keep a journal. Find a friend or relative who can provide a safe, private place where you can do your writing and stash your journal. It isn't safe for you to keep it where your abusive partner can find it.

You don't have to write in your journal every day. It doesn't matter what you say or how few words you have time to write. Just make a note of whatever is foremost on your mind at the moment; whether you mean to express doubts and fears, or the joy of a moment of peace you have salvaged for yourself. Each

time you have a chance to write, look over the words you have written on previous days to keep your earlier messages fresh in your mind and to watch the progress you are making.

Remember that self-talk is not meant to fix all of your problems; it is a foundation from which to recover your Self, and a way to counteract verbal assaults while you are still living with an abusive partner. It's not a permanent solution and it will not change your partner. It is damage control for your Self.

Observing Your Reactions to Increase Your Awareness

Your reactions can sometimes act like fuel for your partner's anger. Remember that getting you to react to him is one of his goals. When you become the one who is hysterical or angry, or giving long explanations for how you act, he is able to transfer his guilt, fear, or anger to you. He can (and often does) say, "See, you are the one who is yelling; you are bawling me out; you are nagging me; you are raising your voice—you are the one who is abusive." Even when he does not say these things out loud, he is able to assume they are true when you react strongly to his goading. That lets him off the hook. How can he be doing anything wrong when you are the one who is "going off on him"?

Harriet told me about an interchange between herself and her partner, Joe, that illustrates how he goaded her to get a reaction out of her. These dialogues between Harriet and Joe were related to me by Harriet:

JOE (goad #1—an accusation of some kind): [Harriet said:] "He would get up and go in the kitchen and start: 'You never cook.'"

Harriet demonstrated how she launched into her long explanation of how she always cooked dinner and ended with "There was [always] something cooked or cooking on the stove [or] a casserole in the oven, you know."

Joe (goad #2): [Ignoring Harriet's long explanation.] "What about Darcy—does she cook for her husband?"

Harriet: "Yeah, but I cook for you, you know I do. How can you just stand there and say that?"

Joe (goad #3): [Again ignoring Harriet and changing the nature of the accusation.] "Well, why can't we eat dinner when I want to eat?"

Harriet again gives a long explanation about how hard it is to schedule a mutual time for dinner, and tells Joe how she is willing to compromise.

Joe (goad #4): [Paying no attention to Harriet and again changing the accusation.] "You never fix spaghetti."

Harriet [to me]: "Then he started telling me what he liked to eat."

Joe (goad #5): "You never cook for me." (A return to goad #1.)

This interchange of goading and reactions shows Joe had something else in mind than getting Harriet to cook dinner. Harriet was trying to compromise, and above all trying to explain. Joe paid no attention to her explanations. He was too busy thinking about the next thing he could say that would get a reaction out of Harriet. This pattern of goading (accusing) and explaining is so typical, it was reported by many women. The subject of the goading is often cooking or what is cooked, and often it is about housework ("You never dust in here") or child care ("You don't even know how to give that baby a bath").

The longer you live with an abusive person, the greater the tension in your life. You become increasingly reactive; jumping at small noises, sleeping badly and differently; sometimes becoming more abusive yourself; defending yourself from the things he says and does to you until defensiveness is part of your personality, as Harriet demonstrates with her long explanations, a typical reaction by many women.

One thing you can do is to learn to observe yourself as you react. If you yell back at him, or yell at your children, take a mental step backward and watch yourself. Just notice your reac-

tions, don't make any judgments about them. Just ask yourself, "Is this the way I always acted? Is this the way I want to act? Would I act the same way if I lived in a calmer atmosphere?" Remember that you are doing the best you can, given the circumstances you are in. *It will be hard for you to change your reactions until you change your circumstances.*

Watching yourself react in this detached way makes it easier for you to slow down your reactions, because it is easier for you to see how they are hurting you more than they are your partner. They may be exactly what he wants. Remember, too, that he may continue to prod you until you do react. The most you can do in that case is to quietly refuse, in your own mind, to accept the guilt, anger, or fear that he would like to transfer to you, regardless of what he says or does—and regardless of how you have reacted this time. Many women feel that they are allowing themselves to be walked on if they don't react with a strong verbal or physical defense. A strong defensive reaction may make you feel better temporarily. In the long run it may hurt you as it robs you of your Self.

So, exactly what can you say to stop the abuse—or can you? Here's another exchange between Harriet and Joe, typical of many abusive relationships, when Harriet got fed up with the constant arguing:

HARRIET: "Okay, already. All right. Just all right. Okay. That's enough arguing."

JOE: "Shut up! See, that's how you are."

HARRIET: "Okay, all right."

JOE: "See? Shut up."

HARRIET: Okay, all right."

JOE: "See, there you go again, just shut up."

HARRIET: [In a whisper.] "All right."

JOE: "There you go."

HARRIET [to me]: So, I didn't say nothing. I just shut up.

JOE: "Here we go, you're going to turn into a stick-in-the-mud and you're not going to talk to me. You're off on another planet. You're not going to say nothing to me now."

HARRIET [to herself]: "Oh, no, this is unreal."

HARRIET [to Joe]: "Joe, make up your mind, which do you want?"

JOE: "I said, shut up."

HARRIET [to me]: "He would do like this—but if I did shut up, he would smack me . . . and this would be like every day. . . . I feel like I'm playing with Chinese puzzles and I don't know how to put it together, and they're all in pieces."

This dialogue between Harriet and Joe demonstrates why I cannot tell you the right words to use to change this kind of relationship. No matter what Harriet might have said, she probably could not have ended the argument or stopped the abuse. If she simply walked outside to get away from Joe, the abuse could have escalated, as Joe would likely follow her and continue his harassment. Many women who are being harassed on a verbal level and are not in danger of being physically hurt do leave the house at a time like this. It almost always helps for the time being. Everyone gets a chance to calm down and meet at a later time when the atmosphere has changed. Please remember that I said that leaving the scene helps *for the time being*. It has little effect on the overall pattern of the relationship, which is still abusive.

Abusive people are concentrating on somehow meeting their own needs, on expressing an anger or anxiety or fear that has nothing to do with what you are saying or doing. The dialogue is going to go in whatever direction the abusive person wants it to, most of the time. Sometimes it ends in a physical fight. Sometimes it ends in the abusive person running out the door. There are times when walking out the door to spend an evening on his own is exactly what he had in mind when he started the goading and harassment. When you react strongly enough, his guilt for leaving you alone is gone in his excuse: "Who wants to spend the evening with such a nag [or bitch] anyway?"

I could tell you that you can experiment with different verbal reactions, such as telling your partner to "stop it"; or trying not to react at all (using silence); or walking out of the house (NOT

recommended if you are being physically abused, unless you have made a safe, detailed plan of where to go and how to get there); or responding in a calm, quiet manner. But what I can't do is give you guarantees that any of those things, or anything else you may choose to try, will work; and I can't guarantee that they will keep you safe.

Helen, living with verbal abuse, found greater peace before she left home if she could cultivate a habit of detaching from an abusive scene. She said she did that by trying to impassively watch her partner as he raised his voice and went over her latest faults. When she could do that, she felt much better about herself. But she couldn't always manage to react with calm detachment. And it had no effect on her husband's abusive talk.

It is important to know that if all you can do is to become more aware of how you are reacting to him and how it is affecting you, you will have done quite a lot, as long as you remember not to judge yourself for how you have reacted. Realize that you are doing the best you can. It may be all you can do for as long as you decide to stay in the relationship.

Awareness is the plug to use to keep your Self from draining away as you react to an abusive partner. The purpose of being aware is to conserve your strength; to make it easier for you to decide what you want to do with your life—not to help you stop an abusive person from being abusive. I can't imagine any words from you that can do that. Sometimes it helps calm things down if you react in a calm way to the abusive prodding described above. But, sometimes a calm reaction, or none at all, can make an abusive person angrier.

Sometimes violent words are the symptom of tension building up in an abusive person; and that can often mean that they will be followed by physical blows. Above all, as long as you are living with an abusive partner, the most important thing to consider is your own safety. It is up to you to know how to react, or not react, in the particular situation you are in. If you can't find a way to be safe no matter what you do, call the battered women's hotline immediately and ask for help. Aware-

ness is valuable to you as a help in making your decisions, but it can't keep you safe. There comes a point when you must stop wasting time and jeopardizing your health and your life. Make the call.

Explaining and Apologizing

Abusive people often ask us to explain ourselves. It is only natural for most people to try to answer them as Harriet did in the dialogue with Joe above. In order to do that, women often find themselves explaining or apologizing almost as if they were saying, "I'm sorry for being me."

Abusive men often ask such innocent-sounding questions as: "Why do you wear your hair that way?" "Why didn't you dust the furniture today?" "Why did your mother think she had to buy our son those shoes?" "What happened to the leftovers in the refrigerator? I suppose you ate them." "Did you see there is an orange rotting in the fruit basket? Can't you take care of those things?" "Who left that mop in the bathroom?" "Why did you make fish for dinner? I told you I had it for lunch." (He did?) Joe's question "Why don't you cook?" (when he was perfectly aware that Harriet did cook) was a question in this category.

The accusatory tone and attitude that goes with these questions often calls to you to react with the fullest possible explanation in order to protect yourself. From what? From his anger? From the guilt he hopes to set up in you? Of course, no attention is paid to your explanation whatsoever. No matter how carefully you explain, he will not be satisfied, but will ask other questions. *He means to meet his own needs. He is not interested in your welfare. He is not on your side.*

I have talked with experienced, professional women who still get caught in making long, unnecessary explanations in answer to questions like those listed above. Don't expect that your habit of explaining and draining yourself away will be easy to get rid of. Protecting your Self cannot so easily become automatic

when you have lived with an abusive person. Your habits of reaction are not so easily broken. It's hard to realize when you are being invaded.

After a while, as you continue to live with an abusive partner, old habits like this can seem to be almost natural and normal. How can we be aware that we are hurting ourselves as we explain?

Your greatest weapon against the effects of your own explaining is, again, to observe yourself. Become more aware of how much of your Self drains away with every word of explaining you do. Your awareness alone is enough to at least help protect you. It helps you to remain more objective, to react less strongly; to detach from the situation and be more successful at not taking what is said to you personally. It helps you to realize that the things that are being said to you are coming from a mind full of fear and anxiety that you did not create.

If you can't stop explaining, don't waste time feeling inadequate, and don't worry about it. Your awareness will help, and when eventually you have a chance to associate with other women who are learning how to recover, their comradeship and support will help you regain and discover more of your Self.

Trying to Please Him; Trying to Be Perfect

As your partner criticizes you and the things you do or don't do, you may react, in common with many women, by trying to predict, to anticipate, what he is going to criticize next and then making sure you have done whatever it is you need to do to avoid his criticism and his anger.

Annette was one of the women I talked with who told me how she tried to anticipate Charlie's next criticism and discovered, as many women do, that there was no real way to please him. For a while Charlie checked the windowsills for dust each night when he came home from work. When she began to dash home early from her own job to dust the sills just before he came in the door, he found other things to criticize. She said

she could never dash fast enough to keep ahead of Charlie's demands.

You may clean the house from top to bottom, fix a nice dinner, clean up the kids, feed them, and put them to bed—all so he will be be pleased and pleasant when he comes home from work. You do all of this even if you have a full-time job yourself. And then, you find that you still can't predict the mood he will be in when he walks through the door. He comes in, looks around the house, lifts the lid on the pot on the stove and sniffs, walks into the bathroom, and yells at the top of his lungs, ''Well, couldn't you have at least gotten out a fresh roll of toilet paper?'' (The kids used the last of the roll minutes before he walked in the door.) The mood of the romantic candlelight dinner you have prepared is spoiled. The moral is: *He will always find something wrong no matter what you do.* No matter how hard you try to anticipate his every desire and need, he will find something you didn't do; or something you did do that he, at the last minute, has decided he didn't want you to do.

You may believe me when I say that he will always find something wrong, but you will probably continue to struggle to be perfect. Notice what is happening to you. The ''perfect'' you are trying to be is his definition of ''perfect.'' It isn't yours. And his definition is always changing. He doesn't mean to allow everything to be perfect—ever! Try to be aware that it's almost impossible to keep up with what he wants done and how he wants it done. No one could do it. Notice, too, that your partner is using this critical attitude to withhold his love and his regard from you. How perfect do you think you would have to be to finally get his love and his approval? You know it isn't because you don't deserve it. You do! As long as you decide to stay in the relationship, you may need to stop expecting him to express his love and approval to you. You may need to stop expecting him to be physically affectionate outside of sexual episodes; stop expecting him to treat you tenderly. And that's a sad way to live, isn't it?

The main effect on you of your efforts to please him is that

you lose track of what it is you want; what you like to do; what you like to wear; what you want to do with the kids and with your life. You lose track of *you*. It's almost as if you don't exist. Everything revolves around him, and you may think that's the way it is supposed to be. But the cost is too high. You are too valuable to lose. When you devote yourself so totally to another person, you disappear. When your attention is completely taken by what he does, there is none left for you. When you shift the focus of your attention away from trying to please him when he can't be pleased, your whole life can shift in another, more positive, direction.

CHAPTER 6

Start Finding Out What You Really Want to Do

Whether you have decided to stay with or leave an abusive partner, it will help if you can find a specific way to get back in touch with your Self. It will help you to find out what you really like and want to do; to reach a point of self-awareness that can help you build a vehicle designed to carry you into a new life; to begin to heal your self-loss and then start to organize new plans that you may have been thinking about for a long time.

One of the things you can do about this kind of self-loss is to start making lists of things *you* like. If you think it could be dangerous (and it often is) for you to be caught making these lists, or dangerous for your partner to read them, try constructing lists in your mind and memorizing them. That might even add to the magical effects these seemingly simple lists sometimes have to focus your attention on yourself and your self-development. Another alternative is to work on your lists at the same time and private place you have found to work on your journal. A good book to read is *Wishcraft* by Barbara Sher for suggestions about how to find out what you really want and how you can get it.

1. Make a list of your favorite colors: the ones you like to wear, the ones you want to have around you in the drapes and furniture and on your children, and in the flowers you like to grow. Describe why you like these particular colors—how they make you feel.

2. Make a list of your favorite foods. How often do you get a chance to have them?

3. Make a list of your favorite people and why they mean so much to you. How often do you get a chance to see them?

4. Make a list of things you love to do. List the things that really absorb your attention: activities from which you derive a feeling of accomplishment, or a lift of your spirits. Consider whether or not you are free to do any of these things. Or maybe it's been so long since you were free to do what you love to do that you find it almost impossible to list more than one thing. Keep working at it until you have at least twenty things on your list. Anything goes, from watching a sunset to plumbing a house to playing the guitar and reading, writing, or dancing. Helen said that it was on just such a list that she first wrote, "I love to write. I want to write professionally," at a time when that seemed like the last thing she would ever be able to do. She eventually became a writer.

After you have made this list, 1) mark each item with the date that you were last able to do that particular thing; 2) put a dollar sign next to the things that cost money to do (you can decide to spend more time doing some of the things—or at least one thing—you love, especially those that cost little or no money); 3) mark a *P* next to the items that you can't do unless another person is with you, and list the person with whom you would like to do them. Do you dare to arrange to do just one of the things you would like to do with another person? Don't do it yet if you think it will put you in danger.

5. Make a list describing your environment exactly as you want it to be. This list is a combination of the others. If you don't make any other list, try to write this one down somewhere and keep adding to it as you think about it. Again, list the colors

you love and want on you and around you; the people you want in your household to live with, even if you have to make them up—describe them in detail; the atmosphere you want—do you want quiet and peace or do you want laughter, music, and lively activity? What do you need around you to do some of the things on your list that you love to do? Add these items to the bottom of your lists. Do you need books and bookcases? Gardening equipment? A tennis racket? A good chair or mat for meditation or exercise? A stereo/tape/disc player? Dancing shoes?

Consider what food you want to have around for yourself to eat. What clothes do you want to wear? A lot of women take what other people want into consideration, but they don't leave out their own preferences completely. Are you doing that?

As you construct your lists, give them careful thought. For the most part, work on one list at a time so that you can absorb what you have written or thought about. Later, you may find that adding an item to one list reminds you of something you would like to add to another and you can work back and forth between lists. Let your mind roam free. Don't put any restrictions on your dream lists. Do you think you can't afford the things you put down? Do you think you can never do the things you've listed? Never mind, just put down everything you can think of.

Be careful not to define yourself by what you do, by the roles you play in your life—Joe's wife, Darlene's mother, or Amy's secretary—but by who you are. Your preference lists are reflections of who you are. Don't waste your time feeling sad at the contrast between what you want to do, what you want around you, and what your life is like now. Just use your knowledge of that contrast to work toward the life you want. Gradually, as your mind clears and you are more sure of yourself, you will almost automatically (or magically?) work toward the kind of life you describe in your lists.

Many women, and men as well, suffer from problems of self-definition. But when you are, or have been, living with someone who is treating you abusively, it is harder to maintain your

definition of your Self and harder to heal from self-loss. The next two steps in the process are: 1) to enhance your physical and emotional health, and 2) to make your first efforts toward coming out of your isolation.

Your Physical, Mental, and Emotional Health

You have been concentrating on your partner. It may have been a long time since you took care of your emotional and physical health. You need all the physical and emotional stamina that comes from good health in order to be able to follow through on what you decide you want to do with your life.

There are a lot of resources available from which you can learn what a nutritious diet should consist of, how to exercise to gain strength and stamina, and how to nourish your spirit. Consult the resources that fit your lifestyle and work to enhance your health and strength. It's hard to be emotionally strong when your body is tired and listless. And when your emotions are in a depressed state, it's hard to find the motivation to begin a program of eating nutritiously and exercising regularly. One place to begin is by taking short walks and putting one foot in front of the other for even five or ten minutes each day.

Anyone who lives with never-ending stress often forgets, literally, to breathe. In the process of tensely waiting for the next thing to happen, you may be almost holding your breath. Your breathing may be shallow and your body deprived of oxygen. Begin to practice breathing deeply. This is one ideal place to begin to increase your physical well-being, because you can do it almost anywhere you are without alarming your partner.

Find a quiet place to relax several times a day. Even five minutes of practice can be helpful. Breathe in slowly through your nose with your mouth closed, counting as you inhale. Hold your breath while you count again and then, still counting, slowly release your breath through your nose. Start with a count of five at each step and gradually increase the count as you practice. Try five or ten deep breaths in the morning and again

at night, or whenever you get the chance. There are a lot of different deep-breathing methods that can enhance your well-being. If it is possible, get audiotapes or books from the library and use them as instructions for deep breathing and meditative exercises (for example, see Jon Kabat-Zinn's audiotape, *Wherever You Go, There You Are,* 1994).

I urge you to find a few moments each day to practice deep breathing and meditation. It is one of the most effective ways to begin to recover your spirit. In a few weeks you may notice an increase in your energy and your motivation to take the next step. Then it's time to look for the best books, or appropriate radio and television shows, or people in the fields of nutrition and physical and spiritual development, to provide the information you need to expand your self-enhancement program.

If you have been part of a formal religion, attend the church or synagogue of your choice. If New Age spirituality or self-help groups are more your style, go to meetings and keep in touch with people who are involved. Or spend time in natural surroundings to feed your spirit. Without nourishment for your spirit your attention to rebuilding yourself can turn into an ego-inflating exercise. Instead, it is the nourishment of your spirit that guarantees the development of a healthy Self.

If you feel restricted from doing any of these things by your fear of what your abusive partner will do, try to become more aware of how you feel about living such a restricted life. Again, ask yourself the question "Is this the way I want to live?" And trust your own answers.

If you do not feel safe enacting any of these suggestions, postpone them until you have reached a safe environment like a shelter for battered women or the house of a friend or relative *whom your partner does not know about.*

Now It's Time to Begin to Break Out of Your Isolation

If you have followed some of the suggestions made in this and previous chapters, you have come to a time and place when

you need other people to talk to. It's time to find the people you need to help you transform your lists into a description of your life. Here are a few suggestions to help you begin that process.

1. Reconnect with friends of the same sex. It is not safe for you to make new opposite-sex friends at this vulnerable time in your life. Your partner may assume you are having an affair, or you may be jumping into the fire from the frying pan if you go directly into a new relationship from an abusive one. Wait until you have learned more and begun to heal your wounds and recover your Self before you risk another relationship with a man, or a woman, as the case may be. If you are a woman, how do you find supportive female voices, even before you leave your abusive partner? Many of the women I talked with told me stories about how they found a woman friend—someone who had been in their lives all the time.

Annette's life fell apart after she and Charlie separated, and she needed help. She didn't know where to turn. She thought she had no friends of her own. All of her children had grown up except for one son who was still at home. And now she felt completely alone. Her husband, Charlie, had always told her, "You have no friends. The only friends you have are my friends." Annette had believed him. That's why she never really noticed Caroline, a woman who was the wife of one of Charlie's friends. Caroline had been coming to Annette's house for years with her husband. She had picked up Annette's son occasionally and taken him with her when she took her own son to a game or even shopping at the mall. One day, just when Annette thought that she was completely alone, Caroline appeared at her door and asked if there was anything she could do to help. Annette cried and asked Caroline to take her to a doctor. That was the beginning of the happy ending to Annette's story (see Chapter 11 for more about Annette).

The point is that Caroline had been in Annette's life all the time, always ready to be her friend. But Annette had been too

isolated to even look up and see the friendship and support in Caroline's eyes.

Linda was one of many other women who told me similar stories. Grace, an older woman who lived in the same apartment building where Linda and Tom lived, tried to talk with Linda every time she saw her. Slowly and reluctantly Linda began to trust her. Finally, Linda "adopted" Grace and her family of grown children as a substitute family of her own. She was often invited to their home for dinner, but was welcome there at any time. Linda spent many happy hours in their company. One of Grace's daughters had lived with an abusive husband for five years before successfully reconstructing her life with the help of the advocates in a shelter for battered women. It was from her that Linda learned the phone number for the hotline. Grace and her daughter repeatedly told her, "You have a right to a relationship where you are not being hurt; where the person you are living with treats you with respect and love." Linda said they always ended their cheerleading sessions with her by saying, "And now, call the hotline." After a severe beating from Tom, that's exactly what she did. Tom had objected every time Linda left to visit Grace and her family, but Linda found ways to keep in contact with them anyway.

So when you are looking for a way to reconnect with other people, look around at the people you already know. There may be a woman whom you have already met who has been hoping to talk with you. Meet her at least halfway. You might be able to develop the kind of trusting friendship you need so badly; someone to whom you can repeat your new messages about yourself out loud. You don't have to tell her all of your intimate secrets right now, but you may at least gradually begin to express an opinion and listen to hers in return. You can take the first step out of isolation and see where it leads. If your partner knows about your new friendships, he will likely object and try to limit your contact with them. He may do that in any number of ways. For example: he may insult or criticize your new friends; he may object to your leaving the house; or he may

accuse you of going out to meet a man. Make note of his objections and ask yourself if you want to live your life without friends.

2. Call the hotline. Now is a good time to call the hotline for battered women as another effective way to pull yourself out of your isolation. When you call the hotline, it does not mean that you have made a decision to leave home; it just means that you have a lot of questions and you need to talk to someone who can answer them for you. Many of the local hotlines are available twenty-four hours a day. The national hotline is available if you cannot reach anyone locally (see the "Resources" section in the Appendix). If you can't make a call from your home, find a friend whose telephone you can use. Or make the call when you are visiting your mother, or another understanding friend or relative—one who won't talk to your partner about the telephone calls you are making. Take the advice of the people you talk with on the hotline.

3. Join a group of women. Through your hotline contact find out if there is a group for battered women that you can attend on a regular basis to help you decide whether or not you want to stay in the abusive relationship you are living in. Be sure you are safe as you try this option. If your partner uses alcohol or other drugs, call Al-Anon and consider attending meetings if it is safe for you to do so.

There are many ways to bring yourself out of isolation. If you are still living with an abusive partner, take slow, safe steps as you begin to make contact with other people again.

Awareness and Permission

Notice that you may think you need permission from at least two people to do any of the things suggested in this chapter: your abusive partner and yourself. I suggest you forget about asking permission from him. As your awareness of the situation you are in, and the power you have to do something about it, increases, it will be easier for you to give yourself permission to

continue. I have suggested a rather complex program; this chapter and the previous one may be overwhelming at first. If you feel that it is, pick one place, and one activity, where it is easiest for you to start, and do so. Silent and invisible deep breathing may be the simplest place to begin. Use these suggestions to build a program for yourself. But being human is all the permission you need to get started.

Read this book and, whenever possible, do the suggested exercises somewhere away from your abusive partner: at the home of a friend or relative, at the public library, or in the park on a beautiful day if you can get out without calling attention to what you are doing. Later you can do them in a group with other women who have been or are being abused; or with a knowledgeable, effective counselor who is on your side. If you are living with an abusive person, keep in mind that it is not safe for you to leave any written information for him to find.

Call for Help

These brief suggestions can help you gradually regain your Self, gain the strength you need to keep yourself safe and to enhance your ability to make decisions about your life. If you are in danger right now—and you always are in some degree of danger if you are being physically abused—forget everything else and call the battered women's hotline nearest to you, or the national line, for immediate help. You can come back to these suggestions when you have reached a place of safety. But if you are not ready to make that phone call yet, read on.

GETTING HELP

Have You Decided You Could Use Some Help? How Do You Find It?

Have you decided you want to make some changes in your life but don't know where to begin? What kind of help do you need, and how do you decide where to go and what to do out of all the choices you have?

No matter what kind of help you are trying to find, the first and best recommendation I can make to you is: CALL THE TWENTY-FOUR-HOUR HOTLINE FOR BATTERED WOMEN NEAREST YOU or CALL THE NATIONAL HOTLINE NUMBER. Consult the "resources" section in the appendix of this book to find the national number. Again, if you need help in a hurry call 911 or the police. The people you will speak with on the hotline are experienced in all aspects of violence in the home, and they know where you can find the help you seek and who you can count on to assist you with whatever problem you need to solve.

First describe your circumstances to them and then get a recommendation from the hotline about what kind of help you need. Get from them the names of professionals who will be the most effective in helping you; those who are knowledgeable about domestic violence and who will keep your safety uppermost in their minds. Call from a friend's house or a pay phone

if you have to, but make the call. It may sound simple. I know it isn't and so do you. But it's doable. That first phone call is the only step you will need to take alone. In Chapter 8 I discuss more about what you can expect when you contact a shelter or hotline for battered women.

Regardless of where you look for help, you need support from people you can trust. You need to surround yourself with people who will encourage you and offer you validation and support.

Even after you reach out for help, you still need to be able to judge for yourself when someone is truly on your side, whether that person is a friend, relative, co-worker, employer, psychiatrist, social worker, policeman, attorney, medical professional, or advocate in a shelter for battered women. There will be times when advocates for abused women cannot be there to advise you; times when they don't have any knowledge of the people whom you need to ask for help; times when you are not able to contact them. The following description may help you to identify those people who can help you most effectively. This is a general guideline to call your attention to characteristics of people who are truly on your side. You may not find all of these characteristics residing in the same person. Always use your own best judgment.

You can rely on someone who:

1. Really listens to you without passing judgment on anything you may have said or done in order to defend yourself from abuse.

2. Truly believes what you tell her, and understands that you are being criminally assaulted through no fault of your own. If you hear even the slightest hint that the person you are talking with is blaming or judging you for being abused, your listener/helper is not the kind of person you need.

3. Tells you that you are the one who is responsible for rearranging your life, while offering to help you do it. This may

be one of the most trusting and supportive things another person can say to you.

4. Holds what you have told her in the strictest confidence; does not tell anyone else what you have confided in her without your permission, or only when it's necessary in a state of emergency.

5. Will research additional resources you need when you are so closely monitored by your partner that it is not safe for you to make your own phone calls for information.

6. Understands the need to take care of herself to avoid getting hurt by your partner.

7. Does not tell you either to stay with your partner or return to him, but suggests that you do get in touch with experts in the field of domestic violence and gives you the nearest hotline phone number, or just listens to you until you can decide for yourself what you want to do.

8. Is clear, realistic, and honest about the kind of help she can offer you. Maybe she can be a voice on the telephone when you need it; maybe she can take you to the police station or to the pickup point for the battered women's shelter if that's what you need; maybe she can keep a suitcase packed for you in her house with a change of clothes for you and your children; or maybe she can offer to take you into her house if you need to get away from your abusive partner very suddenly, and until you can make other arrangements. Any of these things are helpful. If your abusive partner knows your helper, she could be in danger. It's a good idea to be clear about what your friend is offering and exactly what you expect from her.

9. Is willing to help you do something that you tell her you have decided to do—even when your helper has had no part in planning your next step.

10. Would not think of taking any steps on your behalf without first asking you if that is what you want to do.

11. Will not "baby" you, but will encourage you to take the next step yourself whenever it is possible for you to do so.

Don't let your own guilt for the reactive abuse you have done to your partner or your children keep you from looking for help now. It is typical for most women who are abused physically or verbally to become more reactive, more defensive and tense, and—yes—abusive themselves over the period of time they are being hurt. At some point, in order to defend yourself, you may have begun to trade criticism for criticism, accusation for accusation, and abuse for abuse within your family. It is not unusual for the whole family to take on reactive, abusive patterns. Even though you are only reacting to a long history of abusive treatment, you may be seen as abusive by other people. They may think you are the instigator of abuse in the family, since your "Jekyll and Hyde" partner has often shown other people only his good side.

You can't afford to have anyone in your chosen support system who believes you have initiated the abuse from the beginning; someone who has not witnessed, or fails to understand, the isolation, intimidation, and control that you have experienced at the hands of your partner.

There is a big difference between a helper who blames you for the abuse you are suffering and one who holds you responsible for doing something about it. You are the only one who can decide to act. Your helpers can offer support without blame.

There may be times when a helping person will not do something for you that you think she should do. Leave that up to her. She knows what her limitations are. She may be reluctant to step over into the realm of things you should do for yourself, knowing that if she does so, she will only weaken you. No matter what her reasons for refusing aid, accept them and be grateful for her existence. A refusal from one person only lets you know that you need help from more than one source.

When members of your own family fail to give you reliable support, do not despair. Many women eventually collect around themselves members of a new "family" that they substitute for their original family members, just as Linda did. Some of the women I talked with who were in a shelter for battered women

said they only got supportive phone calls from a parent or a brother or a sister *after* they had reached the safety of the shelter. I can't be sure of all the reasons why this should be so.

Eileen didn't have much support from her mother or sister and brother during the years she was being beaten by Marcus. She told me that she didn't talk to her mother about Marcus's abuse because "she would hurt me by not wanting to hear it. . . . She would always make me be the bad guy."

Eileen said that her sister was always so involved with her own life that "it is more or less like she didn't want to be bothered" (with Eileen's problems). But after Eileen had sought protection in a shelter she said that her sister sent her a message saying "that she loved me and if there is anything she can do [to help] to let her know." She said her brother had once silently stood by and watched Marcus abuse her, but that since she'd taken refuge in the shelter, he was now "singing another tune" (and offering his help).

Family members often have been more frightened of an abusive partner than anyone knew. Or they were in such a state of denial that they didn't say anything until after their daughter, sister, or mother took the courageous step of entering a shelter. Her action in her own behalf sometimes opens their eyes to her dilemma. Once she is safe in the shelter they can more freely and openly offer their help to her because they are no longer afraid they will not know how to help her. And they now often believe that she will also try to help herself; that it is not all up to them. Most women reported that only a few relatives offered their support, however, even after they had gone to a shelter.

The point is for you to look for help, trust, and support wherever you can find it. Don't look around you in vain trying to find it where it does not now exist. That's a waste of your valuable energy and strength. It scatters your concentration and your attention. You can catch up on your relationships with people who have been "close" to you later.

Irene had found her substitute family where she worked. She said that her job was her only social life. Her abusive partner

didn't mind her keeping her job because she used her wages to pay most of the expenses on the apartment where they lived together. Irene said, "My only happiness I had was the people I worked with and . . . the customers." Before she decided to go to a shelter for help, she noticed that her supervisor had pinned a brochure from the local shelter to the bulletin board. Then she began to talk to other women she met at work. As she came out of her isolation by interacting with other women every day, she began to see more clearly what she wanted for herself. She found in the midst of her friends a sanity and confidence she hadn't felt for a long time.

Barbara found her substitute family in Al-Anon, a group organized to help men and women who love someone who is alcoholic. She attended meetings during the day while her husband was at work. She gradually built a group of women friends that she could call on for help any hour of the night or day. As she came out of her isolation with the help of her friends, and learned how to refocus her attention toward herself instead of trying to change her husband, she was able to think more clearly and decide what she wanted.

Right now, you need to be supported in making your own decisions. Can you learn to discard those who are not able to help you do that, even when they are your own parent or sister or brother? You don't need to tell them they are being discarded. Later, when you have reached a point and a place where you are free and safe, then is the time to have a big party and joyously reinvite back into your life everyone you temporarily relinquished.

Pluses and Minuses of Looking for Help from Public and Private Sources

1. Escaping to the home of a relative or friend. Look at some of the things you have tried to do before to reach a place of safety from your abusive partner. Have you always run to your mother's or father's home in a time of crisis? Or to the home of

a brother or sister or friend? Did it work? Or did your abusive partner follow you, and threaten all the people in the house as well as you and the children you brought with you? Did you go back to him before you were sure about what you wanted to do, because you felt you were putting people you cared about in danger? Did any of your relatives tell you that it was your duty to go back to your partner?

There may be many stories of women who have safely sought a haven from abuse in the home of a relative or friend, but I've only heard one. The rest were stories of heightened danger for everyone concerned.

Helen offered Barbara a place to stay to get away from her abusive husband, George. Since George didn't know anything about Helen or where she lived, Barbara and Helen were both safe.

When you need to get away from your abusive partner, the safest place to look for refuge is in a battered women's shelter. Call your local hotline to be admitted. They will give you instructions about how to get there or where you can safely be picked up. Again, when you are in a crisis, your call will be given top priority. Someone on the hotline can call the police for you if ask them to do so.

2. Seeking the help of an attorney. The right attorney can be indispensable to you when you need to legally protect yourself to the fullest extent possible; when you need to know how to maintain or regain custody of your children; file for a protection or restraining order; or file for separation or divorce. But you need someone who is experienced with domestic violence issues.

When I talked with Clare, she said that it was her attorney who told her there was no excuse for her to be hit—ever; that even one physical attack was one too many. Until she talked with him she hadn't fully realized that. On the strength of his words she decided not to return to her abusive husband. How do you know where to find an attorney like this? Find out from the hotline.

3. Selecting a counselor. Have you tried going to a counselor (psychiatrist, psychologist, social worker, or other helping professional)? Look for someone who matches the description I have given above as a supportive person.

Many women who have been abused, however, have placed their trust in counselors who confuse responsibility with blame and unwittingly increase the guilt, already so huge, in their client's mind. Be cautious. It is very important that you get the right help. You may be so tired, so debilitated, or feeling so helpless or hopeless that you are not in any condition to find or to choose a counselor who can really help you. And there are many who can. The hotline can help.

4. Calling the police. When you call the police department for help, it is usually at a time of crisis for you. Some policemen understand domestic violence thoroughly and are helpful and sensitive to your needs. Some have little understanding and may treat you harshly. In between, you may find all levels of understanding about domestic violence. You need to be ready for their reaction, no matter what it is. And know in your heart that you do not accept the blame and guilt for being hurt, no matter where it comes from.

The people on the hotline will also know which police districts stand ready to send officers with you when you want to go back into your house to get your belongings, after you have left with only the clothes on your back. They will know when police are willing to help you by transporting you to a shelter, either from your home or from a pay phone on a street corner. Many women expressed their gratitude to police officers who had safely taken them back into their homes to get their children, or the clothing they needed; had brought them to the shelter door in the middle of the night; and had, in one case, gone out of their way to help a woman legally retrieve her small son from the hands of her abusive partner.

To be as safe as possible, have a backup plan. When you need to call the police, have the number for the twenty-four-

hour hotline for battered women handy, and use it if you don't believe that you got all the help you needed.

Remember that being a woman does not guarantee an understanding of domestic violence. A woman I met at a shelter reported a distressing experience to us late one night when she was brought to the shelter by two policewomen after being beaten. Both of them had said to her, "If you wouldn't aggravate him, he wouldn't beat you." This woman knew better than that, even though this was her first experience with either shelters or the police. She felt as if she had been betrayed by her own sex. She knew that the abuse she suffered was caused by the internal state(s) of her abusive partner; that it had nothing to do with her or anything she had done. She knew these women had blamed her for her own abuse. She was in tears from the cuts and contusions she had suffered. The attitude of the officers added unnecessarily to her pain. But they did take her to the shelter—exactly the place she needed to be.

5. Selecting a medical doctor. Doctors are similarly more or less acquainted with physical and verbal abuse and its consequences. All doctors will treat your cuts and bruises or they will admit you to the hospital if you need long-term medical care. Others may be able to spend more time talking to you, trying to understand how you got hurt, and giving you some choices other than going back home to your abusive partner when you leave the hospital. They may give you the phone number of the battered women's shelter and ask if you want to go there; or have someone from the social services department talk to you. Call the hotline to get recommendations when it is within your power to choose your doctor.

Social workers can be understanding and helpful or they can blame you for being in the position you are in. Again, it depends on their understanding of domestic violence, whether they work for a public agency or are in private practice. Women in the shelter often reported that they "were made to feel like shit" when they went to the welfare office to apply for financial assistance.

Other women reported, however, that there were both publicly and privately employed social workers who gave them valuable counsel over periods of months or years, helping them in their efforts to regain custody of their children as well as to restore the health of their bodies, minds, and spirits. And many dedicated workers volunteer their free time to help abused women who need them.

In all of these instances, you will be wasting your time and valuable energy if you try to fight members of the helping professions who do not understand and support your efforts to be free and safe. It is up to you to find the right kind of help. You can't afford to wait for public attitudes, policies, and laws to change, any more than you can wait for your abusive partner to change. Your physical safety and ultimate emotional stability are your top priority. It is your responsibility to use the best source available to you to find the kind of help that is the most responsive to your needs as a person who has been hurt by an abusive partner. Right now the best recommendation I can give you is to call the battered women's hotline, either local or national, when you need any kind of help. Ask them to direct you to the right person or agency to help you. Later, when you are free from your abusive partner, you will have more energy and opportunity to work for change in "the system."

Since the specific questions you may want to ask an attorney or counselor sometimes depend on your own unique situation and on the laws and resources in your state and in your area, ask the experts on the hotline for advice before you make any other phone calls to seek help. Ask them about local, state, and national domestic violence laws, and legal procedures. Ask them how laws that are already on the books are being enforced in your area. Enforcement of these laws can vary considerably in different parts of the country, or even within the same state, town, or city. So, talk to the domestic violence experts before you talk to an attorney or counselor, or anyone else from whom you seek help.

6. Friends. Close and caring friends can play a dramatic role

in helping you, especially in that time period when you haven't quite made up your mind yet to call the hotline. But assume that you've finally decided to accept the help of someone you know. Finding someone to trust is often the first step to positive action out of an oppressive relationship. Evaluate your friend's trust quotient by using the list on pages 90–91.

The story I heard of how Donna became friends with Alice at the place where they both worked is a good example. Alice was being abused by her husband. Donna had often seen bruises that began to glow through Alice's heavy makeup. But she wasn't sure she was being abused until one day when Alice came to work with a big black bruise on her cheek and wore no makeup to cover it.

Donna began to read all she could about domestic violence and women who were beaten so she would understand more about why Alice didn't just walk out and leave her husband behind her. In the beginning Donna thought to herself, "If that were me, I would be gone after the first blow." But when she finished her reading, Donna was able to understand more about why Alice had not been able to walk out of her relationship so easily. She could see that Alice had been gradually isolated by her abusive husband before he began to hit her. She knew Alice had no place to go if she left home. She knew that Alice still lived in hope that her husband could again be the charming person she thought she had met and married. Donna gradually began to understand the insidious double traps of isolation and a Jekyll and Hyde personality. Donna had met Alice's husband and might not have believed that he was beating her if she had not seen Alice's bruises. She said he presented himself as the nicest guy in the world. As she learned more about domestic violence, Donna's original question of "Why doesn't she leave?" changed to "How is she ever going to safely get away?"

Donna's approach to Alice was slow and gentle, letting Alice lead the way. At first the two women went to lunch together a few times during the workweek and Donna simply listened. It

was the first time Alice had talked about her homelife to another woman in several years. Eventually, Donna began to ask Alice to go with her on weekends when she was doing her errands. She listened some more.

The most important thing Donna was doing was to reach out and provide Alice with a ladder she could use if she wanted to climb out of the isolation she was in with her abusive partner. As she talked to Donna and left her house on weekends, Alice was already working at breaking the strands of the web in which she was bound so tightly. In being allowed to express herself as Donna listened, Alice was rebuilding her Self so she could clear her mind, turn her attention away from her abusive partner, and make a firm decision about what she wanted to do. This relationship worked because Donna reached out to help Alice and Alice trusted Donna enough to accept her help. Don't underestimate the effect it can have on you when all someone does is listen to what you have to say. Having a chance to express your Self to a person who is not judging you can give your efforts at self-recovery a big boost.

Donna also stood ready with facts and phone numbers to help Alice make her detailed plans and to help her carry them out. After Alice had told Donna her story, Donna also reminded Alice at appropriate times that she didn't deserve the treatment she was getting. She was informed enough to know that she couldn't act for Alice; that, no matter how frustrating it was for her, she had to be patient and wait for Alice to lead the way, because if she pushed too hard, Alice could rebel, retreat into her isolation, and Donna would lose the opportunity to help her.

Women who have been abused have been affected in ways that other women have a hard time understanding. They can sometimes move fast. But sometimes they can't. That is why, so often, women come out of isolation only during a crisis; when they have been beaten up again. They are forced to act then because they are hurt and afraid.

The last I heard, Donna was still Alice's good friend, and Alice was making progress in the process of breaking out of her

isolation and making a firm decision about what she wanted to do.

7. You. There is one more indispensable source of help that is always with you and always available if you will consult it. When your mind is quiet and your body is still, you can get in touch with the voice that is within you; within all of us. As you are able to uncover and discover your Self, it may be easier for you to hear that voice. As you listen to it with an open heart, it can tell you more about who you are and more about what you want to do. Use your inner voice every time you need it so it can grow stronger. Consult it. Listen to it. Learn to trust it.

What Can You Expect If You Decide to Contact a Shelter or a Hotline for Battered Women?

Who Are the People Who Staff the Hotlines and the Shelters?

The women, and increasingly the men, who work with abused women in shelters and on the hotlines are dedicated and knowledgeable. They do their work with grace and perseverance, usually at a low rate of pay. They generally have the specific education and experience in the field of domestic violence that they need to help you effectively. Patience and compassion are also apparent in most of the advocates I have met. Trained volunteers often join the shelter staff in the work that needs to be done. Many volunteers and staff members have experienced physical abuse in their own lives.

Some of the people who work with abused women are called "advocates." Beyond being counselors, they act on women's behalf in the search for help from social services, including: all aspects of the legal system (courts, attorneys, prosecutors, judges, and officers of the law); the welfare system and all of its branches (including financial assistance, medical care, child welfare, and public housing); and the educational system at primary, secondary, junior college, and university levels (for the needs of both women and their children). They help women

find legal and financial assistance and resources; a job or career; a way to get the skills or training needed to become employable; child care; counseling; appropriate housing, or anything else women need when they decide to leave home.

Who Is Welcome to Use the Twenty-Four-Hour Hotline for Battered Women?

1. Call if you have just been beaten or terrorized and need emergency help in a crisis. Determination of your safety is the first priority. When the hotline operator is sure you are safe, she will then determine what other help you need. If you need safe shelter, the hotline operator can make arrangements for it without delay, providing the space is available. You will be told whether the police can furnish transportation to the shelter or where you can go to be picked up.

2. Call if you are someone (male, female, young, or older) who is being, or has been, physically, sexually, or verbally abused or terrorized by a relative or other person, and you need advice about what to do. If you are a woman eighteen years or older, you are eligible to stay in a shelter. Some shelters throughout the country may be able to welcome younger women. If you are not in a crisis at the moment, but are thinking about seeking shelter, here are some of the questions you might want to ask when you call:

- I am a man who is being abused. Where can I get help?
- Is there an experienced legal advocate on the staff of the shelter to help me with my legal problems? If not, where can I get legal help?
- Can I bring my children with me?
- If I do not bring my children into the shelter with me, am I in danger of losing temporary custody of them in the area in which I live? Are there any long-term consequences if I am not able to bring my children along, at least right away?

- What resources (activities, counseling, education) do you have for children?
- Can the children attend school while we are there?
- What do I need to bring with me in terms of clothes and papers?
- What are some of the rules of the shelter; what is expected of me when I get there?
- What kind of counseling is available?
- Can you help me find a job, or advise me how I can learn new skills in order to get a job? What about schooling for me, even when I'm not sure of what I want to do? What about vocational counseling?
- Can you help me find a new place to live?
- What if I have no money? How can you help me? (A general source of money is the welfare system, but there may be other sources in your particular area. Ask about them.)
- What is the maximum length of time I can stay?
- After I've been in the shelter for a time, what's next? Is there a second-step program where I can go to stay? Or other kinds of reasonably priced transitional housing?

These questions are all obviously about the shelter. Other questions you might want to ask are:

- Can you refer me to a private counselor, or an attorney or other professional person—someone who will understand and respect my situation? Are there any professional people who work pro bono (without a fee)? What questions should I ask them when I call them?
- What steps can I take to be safer?
- What is wrong with me? (A question often asked by abused women. The answer is always "The abuse you have experienced is not your fault. Your actions are not the cause of his abusive behavior." But ask this question anyway. You need to hear the answer as often as you can arrange it from people who know the truth.)

Of course, you are not limited to one phone call or to this list of questions, but can call back anytime you need another question answered, or just to talk.

Women sometimes call hotlines to talk about verbal abuse and how it affects their lives. Advocates understand and appreciate the devastation that verbal abuse brings with it and will offer you references for any kind of help you need. Women are welcome in many shelters to escape from verbal abuse, providing there is space available. Physically battered women are given highest priority because their lives, and those of their children, are in danger and their needs must be met first.

3. Call if you are a relative, friend, or employer of an abused woman and you are trying to help her, either before or after she leaves home or enters the shelter. Advocates can tell you what you can or cannot do to help your friend who is being hurt.

4. Call if you are a perpetrator of abuse who needs to know where to find help for yourself to stop the oppression and violence.

5. Call if you suspect you may be entering a relationship with an abusive person and you need to talk with someone to whom you can express your doubts and apprehensions.

6. Call if you are a member of the general public and need information about domestic violence. You can refer to the appendix at the back of the book for national and state hotline numbers.

Hotline telephone numbers do not necessarily ring into a shelter. Several shelters may share one central number to screen women and answer other calls, or the hotline number may be answered in an entirely separate location from the shelter.

Whether you take immediate action or not, these telephone contacts are useful. They are part of a gradual process of putting an abusive relationship behind you. With each call, you make contact with a knowledgeable and trusted source of information that supports you and tells you that you are not alone. You will find out how you can reach out for help, what your

choices are, and how you can make specific plans so that you are not caught simply reacting to one emergency after another. You can come out of your isolation by taking small steps toward freedom, even over the telephone. When you rip even a small hole in your isolation by making a phone call, you are better able to see where you have been and where you want to go. Breaking away from an abusive partner is never as sudden as it sometimes looks. More often, women need to go through a process of leaving. The advocates on the other end of the hotline can play a vital part in that process.

Unless you are calling in an emergency, you can expect to be put on hold from time to time as other calls come in. Be patient and stay on the line, if you can, when an advocate asks you to do so. You will be helped as soon as possible. Be sure to tell the advocate or counselor who answers the phone if you are in immediate danger. If your call is an emergency, it will be given top priority.

What Happens When I Decide to Go to a Shelter?

You may be assigned to one advocate who is responsible for your progress and well-being. She will guide you through the shelter process from beginning to end. She will assign you to sleeping quarters for yourself and your children. In some shelters there may only be one advocate.

As soon as possible your advocate will do an "intake interview" with you, during which she will want to know the details of your circumstances. It is from this interview that she determines the specific kind of help you will need from her, from other staff members, and from members of the helping professions.

If you have no money, your advocate will advise you about applying for welfare funds, food stamps, housing vouchers, medical care, scholarships, and any other sources of financial assistance available for you in your area. You will be advised of your legal rights to protection under the law and told what your

choices are about filing charges against your partner, or filing for a separation, divorce, or custody of your children. Your advocate will tell you how to apply for your rights, and how to find the legal help you need. She or he will also answer your questions about how you can be affected by the choices you make.

If you need private counseling, your advocate can recommend someone who understands domestic violence and can help you, sometimes free of charge, or on a sliding fee scale depending on your ability to pay.

If you need a job, a place to live, help with child care, or a way to get some training or education, your advocate will put you in touch with the resources you need in each case.

When you are ready to leave the shelter, but you still need a place to stay for some time longer while you make more permanent arrangements for a place to live, your advocate can recommend you to whatever arrangements there are in your area for transitional housing. In some areas this typically low-cost housing is available to women who are coming out of shelters and who are recommended to the housing agency by shelter personnel. Your advocate can tell you how to qualify for it and how to make application.

When you go to a shelter, you have the best chance of being safe, of making valuable new contacts, of learning what you need to know about the abusive relationship you are in, and of coming out of your isolation. If you use any other kind of refuge besides a shelter specifically set up for battered women, be sure to contact the hotline for battered women and double your efforts to find a support group to fill your specific needs. Without the shelter and its personnel to learn from, the voices on the hotline and in the groups are more important to you than ever.

If I Decide to Go to a Shelter, What Will Be Expected of Me?

You will be expected to act in such a way as to help yourself and all the other women who are there to get the most out of your stay in the shelter. That means:

1. You will keep the location of the shelter a closely guarded secret for your own protection and for that of all the other women residing there. You will not meet anyone near the shelter or disclose, even to your own mother, the address or even the neighborhood where the shelter is located. You can keep in touch with family and friends by phone without revealing the number of the shelter to anyone.

2. Read the rules of the shelter carefully and follow them. In most shelters everyone takes turns helping to cook the meals and do the cleaning. You'll have plenty of time to take care of other things you need to get done. You will need to return to the shelter by a certain time in the evening unless you get permission from your advocate to return at another time. This may bother you at first, but it helps organize the shelter so it can function at its greatest level of safety and efficiency. You may hold down a job or go to school while you are in most shelters if you want to; providing it is safe for you to do so.

3. You will be expected to take an active part in the group sessions and the private counseling sessions offered to you.

Do I Have to Stay? How Long Can I Stay?

You have come into the shelter because you wanted to, or needed to. You are free to leave whenever you wish. But, it's a good idea to talk over your decision with your counselor/advocate before you go.

The typical length of stay in a shelter is relatively brief; there is often a limit of thirty days. In some locations the stay may sometimes be as short as seven days, because space is limited

and other women are waiting to get in. But your time in the shelter can be extended if you are making good progress and working hard to rearrange your life. And in many locations there are "second-step" programs or other housing arrangements to help you. The shelter exists partly for your safety and protection, and as long as you are working cooperatively in your own behalf you won't be abandoned.

Do You Want to Bring Your Children with You into the Shelter?

Most shelters now welcome children who come with their mothers. Ask about bringing your children when you call the hotline to make arrangements for coming into the shelter. Children can attend school from most of the shelters, providing it is safe for them to do so. Many shelters have advocates who are assigned especially for working with the children.

You are the best judge of whether or not to bring your children into the shelter with you, and how much you want to tell them about your plans. Are they in danger of being abused if you leave them at home? Will your abusive partner try to use them against you in any way? Is it better for them if you carefully prepare them for going into the shelter? Or will the youngest children unwittingly want to share this information with their father? You can ask the hotline operator to advise you about these questions.

Some abusive men file for temporary custody of their children on the grounds of desertion when their wives go into a shelter. But when the court finds out she has been in a shelter for battered women, there is little danger that the court will continue with the procedure. If you cannot take your children with you when you first enter a shelter, perhaps you will be able to arrange to bring them in later. But play it safe—ask an advocate to advise you.

Although shelter life may take some adjustment on the part of your children, most children do well in the shelter. They

enjoy meeting the other children and they benefit from activities and counseling many shelters plan for them. If you have a positive attitude toward your stay in the shelter, you will probably see that reflected in the attitude adopted by your children.

What Should I Take with Me If I Decide to Go to the Shelter?

If you have time to plan your stay in a shelter, it is a good idea to bring night clothes, extra underwear and socks, and at least one change of clothes for you and your children. It will be helpful if you bring hairbrushes, toothbrushes, toothpaste, shampoo, curlers, and anything else that will add to your comfort. Some shelters provide what they can in the way of everyday necessities from donations they receive, but don't count on their having what you want. Children also appreciate having one favorite toy to play with so they can feel a connection with home. Of course, if you don't have time to bring these things with you, don't let that stop you from entering the shelter. Some solution will be found, and you will likely be able to return to your home later to pick up what you need with the help of a police officer.

Besides survival clothing, it is important to bring with you the following items (check them off the list as you assemble them and then either pack them in a suitcase or other container or keep them all in one place where you can get at them in an emergency):

1. For the children:

_____ medical and school records so that you may enroll them in school if you want to do that

_____ their social security cards or numbers so that you can apply for welfare for them if you decide to do that

2. For you:

_____ the money you have been saving a little bit at a time

_____ a set of keys to your car, your house, and your safety deposit box

_____ your own social security card, driver's license, and credit cards

_____ copies of insurance papers and cards for car, house, AAA, and life and term insurance on your husband

_____ medical insurance cards, including Medicare, Medicaid, and welfare medical cards for you and your children

_____ a list of all your account numbers of bank or stock accounts and records of any other assets you may have

_____ your bank books, if any

_____ copies of your rent receipts or mortgage records

_____ a copy of the last income tax report you or your husband filed

_____ prescription numbers and pharmacy phone numbers to order medication you or your children may need

_____ telephone numbers you call frequently, both personal and business

_____ a recent photograph of your husband

_____ photographs of yourself, if you have them, that show injuries you have endured

Take anything else you think you may need.

It may not be safe to keep a suitcase packed with these things in your house where your partner might find them. If you think it's safe to keep them outside of your house, find someone you can take into your confidence who can keep your emergency belongings at her house; making sure they are available to you at any time of the night or day. Or, again, keep them in one place where you can grab them in a hurry.

What Is the Shelter Like?

There are probably no two shelters for battered women that are alike anywhere in the country. Some are large, solid homes or other buildings in good repair that are pleasant to stay in;

some are not. Some have a few private or semiprivate accommodations; others do not. Some shelters are exclusively for abused women, and sometimes shelters serve women with other problems as well. Your needs and your own dedication to helping yourself will have more to do with whether your stay in the shelter is successful than what the shelter or the accommodations are like. The harder you are willing to work for yourself, the more effective you will be in taking advantage of the help you are offered.

In the shelter you can begin to heal from physical and emotional wounds; find new information about your abusive relationship and about yourself; break out of your isolation; be guided through a morass of legal and other social systems and procedures; be given a road map to a life free from abuse; gain lifetime companions and friends, if you want them, and a brand new start for yourself and your children. It's a lot to offer. It's a lot to get. It's there in two thousand shelters across the country for anyone who wants it.

Safely, Please: How?

There is no way anyone can guarantee you will be safe when you leave an abusive person. You aren't safe if you stay in the relationship either. You are in danger either way. But when you stay you face a lifetime of abuse and an ever-increasing likelihood that you or your children will be seriously hurt or killed. It is only when you leave that you have hope of changing that. And leaving gives you a chance to learn how to keep yourself safe.

In general, your greatest chances to be safe include 1) making detailed plans for any possible circumstances; and 2) developing an attitude of sharp vigilance and awareness of the situation you are in at all times. Even though many women are living in volatile relationships with a dangerous man, they often minimize the danger and the damage that's possible for themselves and their children. Sometimes it takes a period of living a more ''normal'' life before women realize how close they came to serious injury or death before they left a physically abusive home.

A word to anyone who is being verbally abused and believes that she is not in danger of physical attack: Keep in mind that sometimes verbal abuse can escalate into physical abuse with-

out warning, as it did in Barbara's case. You can't predict when this might happen. It is important for you to have a safety plan ready regardless of the level of abuse you are living with.

I have said throughout this book that if you sense that you are in immediate danger, you should drop all the exercises and worksheets and text and call the battered women's hotline without delay and get some help. Unfortunately, you may be the last person to understand the danger you are in, especially if you are largely cut off from contact with other people. When you are isolated it is easy to convince yourself that you are leading a "normal" life. But many women have been maimed or killed after as little as a few weeks or as long as years of living with an abusive partner.

Again, when you live with a volatile person, you are always in danger. The change in him can be sudden and can happen at unpredictable times. The viciousness and suddenness of the physical attacks they experience tell women that any one of those blows can kill them, and many have come close to losing their lives. Can you tell when a smack, a kick, or a cut is going to kill you, blind you, or maim you for life?

Martha, one of the women I met in a shelter, told me about a close call she had when her husband, Dave, attacked her in a sudden "flame of anger." He threw her up against a wall that had a large nail protruding from it. His hand somehow got between Martha's head and the wall. The nail went through his hand before it penetrated Martha's head by a small fraction of an inch. She said she didn't want to come any closer than that to dying.

Sudden anger, on the part of an abusive partner, has nothing to do with anything that you have done. It has everything to do with the mood, or state of mind and body, that your partner is in, and how fearful or desperate he feels; how volatile he is. Your behavior did not cause his fear and anger, and frightening as it is, you can't do anything to control it. Sometimes it seems that anything you try to do to calm him down only increases his anger.

So how can you stay safe? The safest you can hope to be comes from realizing that you are not safe at all. I know I can't convince you, just by writing these words, to get away from this abusive person before you or your children have been seriously hurt. I understand the forces of isolation that hold you to your post the way gravity holds you to the earth. For that reason, I include below the limited steps you can take to be as safe as possible even while you are still living with your dangerous partner.

How Do You Stay Safe If You Are Still Living with Your Partner?

1. If you have been physically abused, are in a crisis, and you need help:

• Call 911 or call the police. At least you can hope to get help and stop an attack. Your partner may or may not be arrested. It depends on how serious the attack has been and the physical damage that has been done to you; it depends on the officers and on the laws in your area. Have the phone number for the battered women's hotline ready. If you don't get all the help you need from the police, call the hotline. Take whatever advice they give you.
• Plan your next step. If your husband is arrested when the police arrive and they take him to jail, call the hotline number as soon as he is out of the house. Ask the advocates or counselors for their advice and follow it as quickly as possible. Remember that under these conditions the time you have is likely to be very limited. You may have a day or two while he is in custody (or you may not) to plan the next step you want to take, to decide whether you want to file charges against him, or file for a legal protection order, or stay somewhere else to be safe, like a shelter.
• You may need medical treatment. If you are admitted to the hospital, your partner may visit you and tell you how sorry he is

and that he will never hurt you again. Your chances of returning home with him in these circumstances are very high. Apologies at hospital bedsides are quite common. Some women say this is the only time they ever got an apology. This is a good time to call the battered women's hotline. Ask their advice. Get their recommendations before you decide whether or not to go back home. Find out what your other choices are.

• Documentation. Keep a record of your visits and phone calls to the doctor, the hospital, the police station, and the shelter. Make sure the contacts you make to get help are a matter of public record. If you have visible injuries get the police, a doctor, or shelter personnel to photograph them and/or make a written report with specific descriptions of how you are hurt. Keep a written record of the dates and times when you or your children have been injured, threatened, or terrorized. Keep these records where your partner cannot find them.

2. If you run out of your house in an emergency:

• Go where he can't find you. If you run to the home of your parents or anyone else your husband knows, stay only long enough to telephone the police and make arrangements to stay at least overnight in a shelter, or at the home of someone your husband does not know, even if he has been arrested. Leave the house you have escaped to and go to a shelter as soon as you can. Make sure you are not followed. If you stay there any longer, you are putting everyone in danger. The fear, tension, and anxiety in your partner increase when you leave the house. You have broken out of your isolation. He is losing control over you and most likely he will be desperate. Even when he has been caught and taken to jail, you have no guarantee that he will be kept there overnight.

• Be aware that he may follow you later. Do not assume, when you run, that if he doesn't follow you immediately he isn't going to, especially if he has a pretty good idea of where you've gone. He may have stopped off at a bar to get more to

drink (if he is a drinker), or gone to a friend's house to pick up a weapon. Again, an abusive man typically threatens relatives with bodily harm if they won't offer his partner up and send her back home with him. Under these circumstances you and your relatives are in danger of being seriously hurt or killed.

3. What to do if you are living at home and you still believe you are not in immediate physical danger:

• You need phone numbers. Memorize the phone numbers for the nearest police precinct, the battered women's hotline, and the hospital or ambulance, in addition to, of course, knowing the 911 number. If your children are small, teach them the 911 number and give them practice in dialing it and instruction about when to use it. When you are out, take quarters with you so that you can make an emergency phone call from a pay phone in a well-lit public place where there are a lot of other people around. And don't hesitate to make that call when you need to do so.

• Work now, while you are still living with your abusive partner, at coming out of your isolation. Talk to relatives, and trusted neighbors and friends. Talk to the person on the other end of the battered women's hotline. Build a relationship with the personnel at the shelter. Begin to get your questions answered about your relationship and about the shelter. The more people you talk to and the more you know, the safer you will be.

4. In some areas you have the choice of legally forcing your husband to leave the house. If you choose this route, be sure you have an abundance of legal help and advice at every step you take. Be sure the legal advice you get is based on a thorough knowledge of the circumstances you face if you stay in your home, and if you don't.

Notice that as long as you are living with your abusive partner, your choices of what you can do to stay safe are limited.

If you wait until you have to run from your partner in a crisis, you are in greater danger, because you don't have time to plan where you're going and what you're going to do; you don't have time to acquaint yourself with people who can be a safety net for you like the police (who may transport you to a safe place) or shelter personnel (who can quickly arrange to take you in); you don't have time to prepare the children. And you are too shaken to think clearly.

Now Assume That You've Decided to Seek Shelter. How Do You Stay Safe?

Before you are forced to flee in a crisis, lay out a carefully prepared plan for going to the shelter for battered women. Set yourself a safe time of your own for going; when your partner is least likely to know what you are planning to do.

The basic elements of a plan for leaving include:

• Again, know the phone numbers you need: for the shelter, the police precinct, and the friend who will hold your packed suitcase. If you think you may forget the phone numbers in your anxiety, write them down and carry them with you. In the absence of other phone numbers, call 911 if it is available in your area. Call the telephone company or the police department and find out now if it is available in your area as an emergency number.

• Prepare your children. Decide whether you will be able to take your children with you or not. Prepare them for your decision, whatever it is. Use your own judgment and the advice of a shelter advocate about what is best for them and for you. Carefully arrange a time and place where you will pick up your children if they will not be at home when you leave.

• Pack your bag. Gather the items listed in Chapter 8 for yourself and your children, and leave the bag with a trusted

neighbor or friend. Be sure it will be available for you when you need it.

• Call the shelter and ask to be screened for residency there ahead of time. If you can, give them an approximate date when you will be coming in.

• Arrange for transportation. Check with the shelter and make sure you can meet shelter personnel at a pickup point or get a ride from the police station to the shelter.

• Mentally rehearse your plan. Go over each step of your plan in your mind until you are thoroughly familiar with it. Then, if you have decided to share your intentions with your children, go over it with them.

• Ready to go. When you have this plan in place, pick up your children and your bag when you decide to leave, make a final call to the shelter to let them know you are coming, arrange to be picked up, and go.

• Going back into your house. In most areas of the country, if you haven't had time to make these arrangements, the police will accompany you back into your house after you have left in order to pick up anything you need. *Never go back into your house alone, even when you think your partner is not there.* Call the police department and ask to have several officers go into the house with you. He could return at any moment.

• When to leave the house. It is often advisable to wait until your abusive partner has either passed out, if he is using alcohol or other drugs, or has gone out of the house before you carry out your plans. The women I met who had gotten to the shelter in the easiest, safest manner were those who acted the part of a loving, calm wife (even though they had been beaten severely the night before) until their partners left the house of their own accord. Then they carried out the careful plans they had made to go to the shelter.

Making any kind of change, even a temporary one, can be very hard to do. But when you have made thorough plans and mentally rehearsed the moves you will make when you need to

leave, the change will be much easier for you to accomplish. When it's easier for you, it will also be easier and safer for your children.

Now, Assume You Are Leaving the Shelter. How Do You Stay Safe?

Now, let's assume that you have gone to the shelter, stayed the full thirty days, and have been successful in finding a good place to live. As you prepare to leave for your new residence, you face danger of a different kind from your abusive partner. Some abusive men will follow, harass, or stalk their partners after they have left home. Therefore the danger you face is more hidden from you. Nevertheless, it is there.

• Your partner will not usually let go of you easily. Your protection depends on how well you understand that you are in constant danger of being followed, hounded, or harassed by your partner after you have left home or left the shelter.

• Keep your new address and phone number a secret. Be careful who knows where to find you. Your partner will use his charm on anyone (including your mother or your closest friend) to convince her that he should know where you are for your own good. He may even engage his attorney, as one abusive man did, to find out your new address.

• Learn the law. While you are in the shelter, learn all you can about the legal avenues of protection that are available to you and do everything you can to take advantage of them. It's easier to follow through on filing a protection order while you are in the shelter, are safe, and have the advice and support of the legal advocates there to help you do it. No legal device you may decide to use will be perfect. But it will give you a legal backup, and more hope of staying safe.

• Learn the limitations of the law. Learn from shelter personnel what you can expect from the criminal justice system in your area. Learn what policemen, attorneys, prosecutors, and

judges can do for you and what they cannot do for you. Get all the help you can from law enforcement agencies and personnel. But remember that none of these people, or laws, can guarantee your safety.

• Find out whether you can count on enforcement of existing laws in the area in which you live. Laws pertaining to domestic violence and their enforcement differ across the country. Knowledge about domestic violence is thorough in some areas; in others it is not. For example, sometimes judges carefully keep children out of the custody and away from the influence of a man who has been convicted of beating his wife, and sometimes they do not. That is one reason why your contact with a local shelter is so important. They can tell you not only the local laws, but how well they will be enforced, and how they will be interpreted, in your area.

• You may be a danger to yourself. If you contact an attorney or an advocate and begin the procedure of filing charges or obtaining a protection order, and then change your mind—you have endangered your own safety.

First, you send a signal to your partner that you don't really mean business. He knows he can walk all over you. Second, and possibly even more importantly, you may lose the support of your attorney and other people who are trying to help you. There are some attorneys who will refuse to work with women again when they do not follow through with legal procedures that have been initiated. Many conscientious attorneys try to take cases free of charge when they can. But they are swamped with domestic violence cases and need to find some way to limit the volume. You must pick the best attorney you can find to help with the first action you take; then carry that through. When you have doubts about what you are doing, call the hotline and talk it over.

• Using a bodyguard. One possible deterrent to harassment from an abusive person is the presence of a strong male—a father, a brother, or someone you hire; the bigger and tougher the better. For at least a while, take your protector with you

wherever you go. The danger here (and there is always some danger) is that your former partner may assume that this man is your new lover and fly into a jealous rage. You have no control over that. Stay alert and take precautions at every turn. Be sure to inform your protector of the danger he is in; and be realistic. Inform your bodyguard or the police if you know your partner is carrying a weapon.

• Stay alert and aware. Cultivate a habit and an attitude of confident awareness everywhere you go. Walk briskly with your head held up. Look all around you. Lock your car. Check the backseat before you get back in. When you are out shopping, park as near to a store as you can and head straight for the door. Notice everything in your environment as you walk.

• Relocation can be a good choice. Some women, knowing how tenacious an abusive ex-lover can be, have taken the trouble to relocate to another town, or even set up legal residence in another state.

Opal and her close girlfriend traveled hundreds of miles to a midwestern city from their home in the South. They both got jobs, stayed with friends and in close touch with the shelter while they established their residency, and then they entered the shelter for a thirty-day stay. Opal's plan worked well because during her stay in the shelter she had a chance to get acquainted with the new city, and shelter personnel referred her to the transitional housing program she needed. Most important, she was out of reach of her abusive partner.

Clare filed for her divorce after she had returned to her original state of residence, across the country from her abusive partner. In her case this turned out to be the safest thing she could do.

• What about defense training? Some kinds of physical self-defense training could increase your safety. At the very least it will probably heighten your awareness and decrease your reaction time and give you a little more confidence. But no guarantees come with this either. A study described to me by one of the advocates at the shelter concluded that even women who are

well trained in self-defense were vulnerable to verbal name-calling or insults. When an attacker was verbally abusive, the victim hesitated just long enough for his attack to be successful.

Carrying a weapon such as a knife or gun is not recommended, because even if you become an expert markswoman, most women are in danger of being overpowered and their weapon taken from them and used against them. A stun gun or spray of some kind may also be turned against the victim of an attack, but is not as deadly as is a knife or gun. If you do decide to use a spray or stun gun, get acquainted with the equipment and practice with it. Rely on your own judgment in using these.

You can try screaming, especially if you are hopeful that reliable help is nearby, or talking to him in a calm voice to try to quiet him down, but be aware that none of these methods carries any guarantee.

What I have said in this chapter may be frightening. But it's all realistic. I only wish I had more to say, some concrete, certain advice that can guarantee you will be safe whether you stay or go. Right now I don't know of any. I hope you will read these words and 1) realize that you already know most of what I have said, and that it rings true for you; 2) know that these words can break you loose from your isolation and hasten your decision to get out of there and to take every precaution to do it safely; and 3) that the shock value of the words you read here will wear off in a day or two and you will absorb the information and accept the state of danger you are in as real, and then take action. Again, don't wait until the next time you are beaten and you have to be taken to the hospital or the morgue, instead of to the shelter.

All that could be done for your safety, and that of your children, is not yet being done. A program such as the witness protection program, like the one set up for government informers, would solidify a plan of safety for many women. But we don't have a program like that yet.

Until there is consistency across the country in existing pro-

grams and laws and their enforcement, and until we implement programs that will help insure safety, we can't be sure that women are being released into a safe world. There are thousands of women, however, who have safely left an abusive man, set their lives off in another direction, and are able to live without fear.

The shelter system and what you learn there is the best chance you have for being safe while you are there and for learning what you can do to be safe after you leave.

SO YOU'RE FREE; OR ARE YOU? HOW TO KEEP FROM FALLING BACK INTO YOUR OLD RELATIONSHIP

Alcohol: Your Use and His— What Does It Do to Your Relationship?

The heavy or frequent use of alcohol or other drugs, whether addiction can be proven or not, profoundly affects human behavior and relationships. It distorts the personality of the user and distracts the attention of all those who live with him or her from the usual business of living. This chapter takes a look at 1) how an abused person is weakened by his or her own use of alcohol; and 2) how a person can be seriously affected by someone else's use of chemicals. Throughout this chapter I will use the terms *alcohol, drugs,* and *chemicals* interchangeably, since alcohol is a drug and a chemical. Alcohol use and its consequences are emphasized in this chapter because it is the "drug of choice" for the majority of people and causes much more death, and individual and family destruction, than any other drug.

How Do You Keep Your Own Use of Alcohol from Pulling You Back into the Relationship?

There is no realistic way of getting an accurate count of the number of people who are being beaten who are also misusing drugs, including alcohol, illegal street drugs, and prescription

medications. But it is variously estimated that nearly half of all battered women may fall into this category.

When you are being hurt by an abusive partner and you are also using harmful amounts of alcohol or other drugs, you are dealing with two serious problems. You may decide to leave your partner. But until you decide to leave your use of alcohol behind you, you will not be free. Remember that alcohol is a drug. Remember that even though any drug acts differently on different people, its use changes how most people act. The more you use, the more it can change how you act, depending on the unique response of your own body to the chemical you are using.

Among other possible reactions, your use of alcohol can take the strength you normally have and turn it into self-pity and helpless compliance. You are less likely to want to get away, or to be able to get away. You are the victim of your own unpredictable reactions and mood swings. You are physically and emotionally weakened. You are less likely to take responsibility for your actions, and more likely to blame someone else for the bizarre things you sometimes do under the influence of alcohol. You are preoccupied with your supply, and your use, of the "drug of your choice," and not likely to be interested in developing a strong sense of Self. You are less likely to be able to hold down a job, go to school, creatively express yourself, or make other moves toward your financial and emotional independence and autonomy. And your chemical use gives your abusive partner another way to manipulate you, since he often takes control of your supply of the drug that is controlling you. Use of chemicals insures a weakened Self even when you are not being otherwise abused.

Below is a description of the symptoms of chemical addiction. Read it carefully, and then decide whether you think you would like to have a professional assessment to determine whether treatment for addictive chemical use is appropriate for you. When your mind and body are drug free, you will be in a better position to fulfill the promises you make to yourself.

Signs and Symptoms of Alcoholism

The journey into alcoholism starts easily in the beginning when you think you are drinking just like everyone else does. About 70 percent of all people in this country over the age of fourteen are using some alcohol. Ten percent of those people, from all walks of life, will become alcoholic. Another group, estimated at 5 percent, will become addicted to other drugs (Gorski, 1989).

Some of the symptoms of addiction are:

1. Unpredictable changes in mood. You may feel stimulated and happy when you first begin to drink and then become depressed as you continue. This is true during any given day or evening of drinking as well as over a longer period of time. Eventually, you will experience unpredictable mood swings even when you are not drinking or using another drug.

2. Depression. Since alcohol is a depressant, depression will often become a chronic state for you as your addiction progresses, even when you are not using alcohol.

3. Protecting your supply of alcohol. You begin to hoard and hide more than enough alcohol to use the next time you want to drink, making sure you won't run out.

4. Preoccupation with drinking. Your thoughts of drinking begin to take precedence over your other activities. Eventually your plans for the next party, or the next drink, become more important than anything or anyone else in your life.

5. A change in drug tolerance. Eventually you will need to use more alcohol to get the same effects you felt when you first started to drink (Johnson, 1980). This is a dangerous sign of the loss of control over your drinking. Next, you will need to drink just to try to feel normal. You are experiencing a change in your body's tolerance for alcohol, and you are losing your choices over whether or not you will have the next drink. Soon, your body will not let you refuse it easily.

6. Drinking alone or in secret. Addicted people tend to iso-

late themselves from others. One reason for this is to keep secret how much and how often they drink. Some people may use a reasonable amount of alcohol (from one to three drinks in a given day) when they are in the company of other people and then drink much more by themselves or with another group after the first party is over. This can eventually turn into solitary drinking.

7. Progression. Alcoholism often progresses in a slow, subtle way, always getting worse. You continue to drink more and more often, and the consequences from your drinking increase in frequency and severity.

8. Denial. It's hard for you to make a direct connection between your drinking and the negative consequences it causes in your life. You honestly believe that other people, places, and circumstances are the cause of problems that are, in reality, the consequence of your drinking. This phenomenon is called "denial." You sincerely believe that alcohol is not a problem for you; that you can stop using it whenever you wish.

9. Morning drinking. When you drink heavily one night, have a hangover the next day, and take a drink in the morning to relieve your shakes, anxiety, or headache, you might not be addicted, yet. But a repetition of this pattern is a serious sign that you are addicted to alcohol.

10. Blackouts. Have you ever had a blank spot in your day or evening when you couldn't remember what happened? Have you awakened in your bed in the morning, unable to remember how you got there or what you did the evening before? It may appear to other people that you are going about your daily business in a normal way, but you may not remember, later, anything you did during that time. If you are experiencing such blackouts (not to be confused with losing consciousness or passing out), the chance that you are addicted is high.

If you recognize that any three or more of these symptoms describes your own reaction to drinking, it is a good idea to get a professional assessment and a referral for the kind of help you

need to stay drug free. Call the battered women's hotline in your town and tell them you need help with a chemical addiction. They will know that your top priority is to stay safe and they will understand the complications you face from the dual problems of addiction and abuse. Ask them for a referral to an appropriate person or organization where you can schedule an evaluation of how your drinking is affecting you, and then follow their advice. You will be safest of all if you are inside the shelter at the time you schedule an evaluation.

Just as you are the only one who can decide if you want to continue to live with an abusive partner, you are also the only person who can decide whether or not you want to stop using mind-altering substances. It's all up to you. But if you are still living with your abusive partner, be aware that he will probably be threatened if you decide to be drug free. He is likely to encourage you to continue your drug use, and may have been the one who introduced you to it in the first place. Remember that one effect of your drug use is to distract you from noticing what your partner is doing to keep you under his control. It also contributes to your isolation, because drug use itself becomes increasingly solitary and involves keeping secrets about your own behavior.

The hotline may also refer you to Alcoholics Anonymous meetings. If not, call AA and attend a few meetings on your own if it is safe for you to do so. The phone numbers are listed under Alcoholics Anonymous in your telephone book. Membership in this remarkable fellowship is available to people all over the country, even in small towns and villages. This organization offers effective help, and it is free of charge. It may be tough for you to walk into your first meeting alone. You can make it easier by asking, when you make your first phone call, if there is anyone who can pick you up and take you to the meeting. You will be made to feel welcome. You may be surprised to see someone you know there. You are welcome to listen to the leads, or sit in on the discussions, as long as you like. You are free to comment, or not, as you wish. No one will

force you to speak. You may, however, be offered a friendly hand to shake as you come in the door and as you leave.

Among the people you are sure to find in these rooms as you attend meetings will be women who have been verbally, physically, and/or sexually abused. Find them by listening to the stories they tell as they lead a meeting. It may be easier to find them when you go to an all-women's meeting. The talk about abusive relationships is much more open there. Use women you can relate to as resources, and as sponsors and friends, to help you in your discovery of what you want your life to be like and in finding out how to transform your dreams into reality.

Don't let your addiction, or heavy chemical use, pull you back into an abusive relationship, or block your awareness of the abusiveness that pervades your life.

How Does *His* Use of Alcohol or Other Drugs Affect You and Your Relationship to Him?

I have asked some difficult things of you. One of the hardest is the suggestion that you turn your attention away from your abusive partner and begin to focus on your own needs; to stop watching his behavior and stop trying to change him, and turn instead to taking care of yourself. It's hard enough to do when your partner is an abusive person. When he is also addicted to a mind-altering chemical, your own life can get lost in your attention to his behavior as you try to get him to stop drinking, or to shield him and the rest of your family from the consequences. Even if your addicted partner sobers up or you break off your relationship with him and never see him again, the reactive habits you developed living with someone addicted to alcohol or other drugs can have negative effects on you for the rest of your life, unless you get some help for yourself.

Taking care of yourself is so important that your ultimate freedom from an abusive, addicted partner will depend on how successful you are at doing it; and how well you learn to allow the responsibility for his abusive behavior and his chemical use

and their consequences to rest with him. Untangle yourself from your efforts to change him. There is little you can do to change the chemical use of another person. Whenever he wants a drink, he's going to have it sooner or later, no matter what you say or do.

There are symptoms common to most people who live with or love an addicted or alcoholic person, born in the heartbreak of watching someone they love self-destruct, and trying to stop it from happening. Another reason you focus so much of your attention on trying to keep him from drinking is the knowledge that when he drinks, he is more likely to abuse you verbally, and physically as well. Alcohol and abuse often go hand in hand when the abusive partner drinks. As a matter of fact, abuse at all levels tends to escalate when alcohol is added to the mix, no matter which partner is using it. You, however, will exhibit at least some of the symptoms listed below in response to his drinking behavior, whether you are drinking or not. To understand some of the ways your life can be deeply affected by another person's use of chemicals, answer the following questions. Do you:

Yes No
- ☐ ☐ Try to hide bottles or needles, or pour alcohol down the drain, so he can't drink or use drugs? Or try in some way to keep him from buying his next "fix"?
- ☐ ☐ Stand at the window when he is out, waiting and watching for him to come home; anxious that the neighbors might see him coming home drunk, or worried that he will be hurt in an accident?
- ☐ ☐ "Walk on eggs" when he comes home, trying to keep the house and yourself and your children as silent as possible so you don't "cause" an argument?
- ☐ ☐ When he says, "I've got to get out of here, this place is driving me crazy," do you take on the blame for this "crazy" place instead of realizing it is his behavior

when he drinks (or when he's hungover) that makes it crazy?

- ☐ ☐ Is your attention focused on solving his problems, cleaning up after him, easing his pain, making excuses for him, or otherwise living his life so that you lose track of your own, and you leave him no responsibility for his?
- ☐ ☐ Is your attention so focused on pleasing him, protecting him, manipulating him (to stop drinking), that you give up your other interests in life?
- ☐ ☐ Does the way you feel depend on how he is acting, what mood he's in? Can you only feel relaxed or happy when he is either absent, asleep, or relaxed himself?
- ☐ ☐ Even when homelife is peaceful for a while, do you tense up, almost holding your breath, while you wait "for the other shoe to drop"; for the next crisis?
- ☐ ☐ Have you lost track of how you feel?
- ☐ ☐ As his behavior deteriorates and he isolates himself more, is your own social circle diminishing because you are concentrating so heavily on him?
- ☐ ☐ Have you noticed that you are in greater danger of a verbal or physical attack when he has been drinking; when he is suffering from a hangover; or when he needs a drink?
- ☐ ☐ Is your attention so strongly focused on the drinker in your family that you give little attention to yourself or to your children?
- ☐ ☐ Have you begun to think the life you and your family are living is normal?

If you answer yes to any of these questions, your attention to your partner's behavior is hurting you. You need some help.

When you live with an addicted person, you learn to accept the blame and shame he projects onto you. He needs to focus blame and responsibility on you when he misbehaves in order to save his own image of himself as a good person. He can't allow his bizarre behavior to be his own fault. It has to be

someone else's, and you are elected. You may begin to feel that, somehow, you're to blame for your mate's addiction (in reality, of course, it can't be your fault—that's impossible). You may think you should be able to control your partner's behavior and stop him from using alcohol. You try to be perfect and do everything you are asked to do to comply with his wishes, to keep the peace in the family and avoid an argument or other violence. You do all this partly in the hope that you can stop him from drinking, and so he will act "normal" again.

You develop rules between yourself and your children (Black, 1981) that are usually unspoken, including: keeping the addicted person's behavior a secret from other people and even from one another; avoiding discussion about what happened in the house the previous night; refusal to feel anything (it didn't really happen) or to trust anyone with the family secrets.

The addicted person's behavior controls family life. Everyone reacts and attends to whatever he does or says. You have concentrated so hard on pleasing someone else that you are confused about who you are and what you want to do. Sometimes you feel you have no right to concern yourself with your own wishes and ambitions, that it would be selfish to do so. It isn't!

You have fallen into a habit of protecting the addicted person and making excuses for him. You willingly call his boss if your partner wakes up with a hangover (or doesn't wake up on time) and make an excuse for him when he can't get to work.

Reacting in these ways can mean that you have developed long-term problems like depression, or lack of a solid self-concept or self-identity. You don't know who you are; your identity is confused by how he describes you, and you are listening to him. You have learned to block your feelings because you've spent so much time in emotional pain and you want to stop the hurt. The good feelings as well as the bad ones are lost as you learn how to numb yourself. You have health problems from chronic stress and not eating and sleeping as you should. It's hard for you to form close relationships because you are not

willing to be trusting, open, and free in expressing your feelings and your needs. The family secrets have isolated you. Remember that isolation, whether or not it's visible to you or other people, is almost always present in a relationship before abuse begins.

If you separate from your partner, your habits of perfection, caretaking, and reacting with guilt and fear will not automatically reach a new, healthier balance. Your destructive habits will linger unless you get help for yourself.

Help that is available to you (without charge) regardless of where you live in the United States of America and many places abroad is in the Al-Anon family groups. These groups offer support to anyone who lives with or loves an alcoholic and who suffers her or his own consequences from it. Their phone numbers are available in both the white- and yellow-page directories in most areas of the country. These groups are designed specifically for family members who have been affected by someone else's use of mind-altering chemicals. Help is also available in many areas of the country from the same organization for children eight years old on up.

If it is safe for you to do so, you can help to insure your freedom by getting in touch with a local Al-Anon group and attending their meetings. This group can help you stay focused on your own life and on what you can do for yourself, freeing you from preoccupation with someone else's behavior—behavior you cannot change. The help they offer is free and available to you in weekly group meetings, or from individual group members any hour of the night or day.

Take any of these suggestions that apply to you and lock in your freedom, your future, your health, and your serenity.

Surprising Grief: How Do You Keep It from Pulling You Back into the Relationship?

Some people expect that women will soar into a bright new life, light and free, as soon as they have shed the weight of an abusive partner. But it doesn't usually work that way. Women who leave their partners during a violent crisis have time to think only about getting away, staying safe from a new attack, and recovering from their pain and terror. But it's not unusual for women who leave an abusive partner to feel a profound sense of loss and deep grief. Many women say that they still love the partner who has been hurting them.

When you first separate from your abusive partner, it may be hard to identify your feelings as grief. It's a new experience. And there is no warning; just a surprising emotional fall into a dark hole that you can't find your way out of. Sometimes this reaction is delayed by several weeks or months. You are often so busy in the beginning rearranging the details of your life that you are not aware of the full force of grief or depression until your life has settled into its new routine. Then you find it hard to recognize it for what it is.

In some ways this kind of grief is tougher than if your partner had died. When you know he's still out there somewhere, it's not only frightening, but you have a harder time closing the

door on the relationship. He's not around anymore, but most of the time you know he could be.

I saw women sitting listlessly for hours in the chairs at the shelter right after they had come in. Some of them showed little energy or emotion. Certainly they were dealing with a lot of changes in their lives and many were depressed, but some of them were grieving too. Advocates told me that it could be weeks or months or even longer before many of the women could sort out their feelings. That's why, when I talked with them, it wasn't easy for most women to identify their feelings as grief immediately after they had left an abusive partner.

When you feel this way, it's easy for you to misinterpret your reactions and to think that the cure for your emotional pain is to return to your partner. Your confusion can pull you back into a dangerous, abuse-filled life.

There is more to your grief than the absence of your partner; more to it than your loneliness. When you can identify all that you are saying good-bye to, you are better prepared to deal with your loss. One thing you can do is to break down your grief into the pieces that make it up so you can understand it more clearly and deal with it a little at a time. Here are four of the most devastating losses you may experience as you leave an abusive relationship:

1. Loss of your sense of Self; of who you are. Your partner's definition of you has been a negative one and you may have come to accept it. He has put you down, insulted you, called you names, and perhaps used you for a punching bag and a target in his games of Russian roulette. If you come from an abusive family, you may also have heard negative descriptions of yourself growing up.

Your separation from your partner has ripped away your only working definition of yourself (i.e., his). If you have never had a chance to form your own authentic picture of your Self, you have nothing to go back to; nothing to remember; just a vacant space where a shining portrait of yourself, created by you,

should be hanging. You have no bright painting you can pull out of storage, dust off, and return to its place on the wall. When you separate from him, you go back to a shadowy, distorted image; a counterfeit of yourself, one that has been drawn mostly by other people who have dabbled at creating you.

2. Loss of your dream. Giving up your dream of how the relationship between the two of you could be, can be like separating from life itself. This dream has been your life. You have counted on it. It's one of the biggest reasons you have stayed with your abusive partner; the reason you have endured the pain you have suffered; one of the reasons you may have looked the other way when he was abusing your children, or complied with his demands when he expected you to join him in their abuse.

Somewhere in the back of your mind has been resting the idea that if you could just put up with it a little longer and learn how to act exactly right, things were sure to change. In the lingering soil of your memories of more tender treatment in the past grows new hope every time he apologizes to you and tells you it will be different from now on. Some of the women I talked with had not heard words of love or apology for a long time; but the hope and the dreams for a better relationship with their partner still lingered in their minds. Remember that Linda had said about the beginning of her relationship, ''I met my knight in shining armor.'' And now that she was in the shelter, both of her eyes still black and other bruises hidden under her clothing, she still dreamed of her lover as her untarnished champion. But even before she left the shelter she had begun to sort out her feelings and face reality. She said, ''I still love that person. [But] as far as me and him gettin' back together, that would never be. It'll hurt for a while. But I'll get over it.''

Another painful part of losing your dream is facing the failure of your efforts to change your partner so you could stay with him (you knew that unless he changed you would have to face leaving him). When a relationship takes this form, this one-up (him), one-down (you) kind of give-and-take (you give

and he takes), there is nothing you can do about his need to be in control over you in order to fill his own needs.

Part of the pain of losing your dream is the responsibility you've taken for the abuse you've suffered and for the quality of the relationship. It's hard to give up trying to "fix" the relationship. You can't fix it. But you can let it go.

3. Loss of isolation. When you separate from the person with whom you have been isolated, there is a wrenching that comes from the rending apart of the system you have been living in together. It is not unusual for isolation to become familiar—and therefore relatively comfortable—to people who live within it. They lose track of the fact that there is any other way to live.

It is when you begin to come in contact with other women again that you may begin to realize how deep your isolation has been, and how it has affected you. In the beginning you may feel uncomfortable in the company of other women. You may not be able to concentrate as you try to listen to other people as they talk. You may feel tired or anxious after being among other people for only a short time. You may have a vague feeling that you want to go off by yourself someplace and hide. The "togetherness" is too much for you. You may think it will be hard for you to "find" yourself with all these other people around.

The weight of being with other people can be a burden at first, especially when they are openly sharing their feelings with each other in a very intimate way, and especially if you also lived in an isolated home as a child. But be patient with yourself. When you can change your familiarity and comfort with isolation into at least a sometime joy of sharing with other people, it is an adjustment that can save your life. Your familiarity and comfort with isolation can pull you back into your relationship with your partner, or with another man who builds an isolated, abusive (but familiar) system for you. It's almost like slipping into a pair of wornout, comfortable shoes with holes in the soles; they feel good, but you are vulnerable to being hurt. Healing from the effects of isolation is one of the most important benefits to sharing your feelings and experiences with other

women in one-on-one relationships, in self-help groups, or in the shelter.

4. Loss of denial, and the anger you feel toward yourself. When your denial begins to lift and you understand how abusive your relationship has been, anger at yourself for having put up with it for so long can sometimes escalate to overwhelming proportions. Just when there are other people, at last, to validate for you the facts that you are not crazy and that the abusive relationship is not your fault—when the denial finally drops from your eyes and from your soul—only then can the pain of your own anger be felt. But now you know what it is. That makes it possible to deal with. Now there are other people who understand. They are there to help you, and to share with you their own feelings of self-anger.

When you separate the pieces of your grief into manageable parts, you can begin to design a new identity for yourself; paint a new picture and build a new dream.

You have a chance to understand why you have *not* failed.

How You Can Get Pulled Back into Your Old Relationship

Again, most women misinterpret the emptiness they feel when they separate from their partners. Your feeling of failure to make the relationship what you wanted it to be, the loss of protective denial, the loss of your dream, and the loss of your partner's description of you, all contribute to your emptiness. It's easy to think the answer to filling the void is to return to your partner. You may think his absence is the source of your emptiness. But having had to live with your partner's abusive, punishing attitude and the way that experience has torn you apart is the real source of that empty feeling.

There is an important point I want to emphasize. Before the understanding and healing of all the aspects of your grief begin, you may confuse your own loss of Self with your sorrow at

separating from your partner. If you think it is your partner you need (or another man to take his place) rather than a fuller, more complete sense of your Self, your confusion can pull you back to your abusive partner and a dangerous, terror-filled life.

Find Individuals and Groups to Help You

The suggestions I will make throughout this chapter and in the next, to deal with feelings of grief and depression, are a continuation of the suggestions for self-development that I made earlier and are based on four assumptions: 1) that you are at least beginning to break out of your isolation; 2) that you are now in meaningful contact with other people on a regular basis; 3) that you are no longer living with your abusive partner, or you are in the process of making plans to leave; and 4) that all women who leave an abusive relationship will experience some level of grief and depression based on the sense of loss as I have described it here.

Suggestions I made in earlier chapters were based on the assumption that you were still alone, isolated with your partner, and needed help to take your first step out of isolation, even while you were still living at home. Now, even though some of the tips I have listed sound similar to what you were doing in the beginning, *they are meant to be shared with other women.* This is a tremendous step forward.

Without contact with many other people, both individuals and groups of different kinds, you are in danger of falling back into the habit of isolating yourself and being pulled back into the relationship, even after you have learned so much about how to get out of it. If you don't have the support you need, it will be easy for you to think that living with your partner is the only choice you have. If you work with knowledgeable people who can help, it will be easier for you to understand your wide range of choices. Your contact with other people may start with one other woman and grow to as many as you like. You may find your support in one-on-one relationships or in groups or

both. You may find your new friends at work, in a support group, in the shelter, or in your family.

Some of your grief, of course, will relate to the fact that you have lost someone you love. If you feel that way, admit out loud to other women that you still love him. Use your new contacts or your support groups to talk about the person you miss. Describe how you miss him. Don't hide from it, but step into it. It's the only way you can get through the midst of grief and come out whole on the other side. When you hide from grief and deny it, it can affect you even more seriously. But please remember the bad times you've had too.

Painting a New Picture

When you first began making simple lists of what you liked as one way to define and form a new picture of yourself, you were isolated and working alone. Now, a few weeks or months after separating from your partner, or breaking out of isolation, whichever comes first, you are free to use other individuals or groups to help you begin to flesh out that picture and try out your new Self in discussions with other women. Start work on your portrait as soon as possible. You can't afford to leave the canvas blank for long, but once you start, take as long as you need to finish it. It's okay if you think of it as a work that is always in progress and never quite finished. I've heard a lot of women proudly say that they are a work of art in progress—always. Some hints about how to paint your new picture:

• First, compare your description of you with his. Separate a piece of paper into two halves by drawing a line from top to bottom down the middle of it. Put at the top of one side "Ways he or others described me," and of the other, "Ways I describe myself now." Write down in detail the names he called you and other ways your partner told you who you were. Then, next to that, begin to write down your new description of yourself.

• Next take another sheet of paper and separate it down the

middle in the same way. In the left-hand column write down a list of what he demanded of you. What kind of person did he expect you to be? What did he expect you to do? In the right-hand column write down what you expect of yourself, and then:

—Have patience. At first you may be able to remember every word your partner used to describe you, but words you want to use to describe yourself may come slowly.

—Notice how wrong he was. As you fill in the second columns, the ones voicing your own opinions of yourself, you will understand gradually how wrong he was. But it's easier to get rid of his definitions when you don't have to defend yourself against them anymore.

—Find the original you. When negative descriptions of yourself creep into the exercise, take yourself to a younger age and try to remember the original you, the person you were before you were hurt. Get down to your essence, the part of you that doesn't change.

—Be positive. Write down only positive words and phrases to describe yourself and your expectations, so you will have a clean, solid base on which to build your new image. Use the work you did earlier, your preference lists about what you like, to help you create an even newer image. Is the work you are doing now any different from the lists you wrote earlier?

Now for the most important part. Be sure to share with other people the results of the work you have done. Use other people to help you spot your own negative descriptions of yourself. Ask them to tell you when they hear you being negative. It is easier to spot your negative tendencies when someone else is helping you. Your job is to listen carefully to the feedback they give you. It is other people who can help you be more aware of what you are doing. And awareness is the first step to changing your thinking, and therefore your actions.

Bringing Your Picture to Life

• Act "as if." Until you can change your idea of yourself more permanently, act as if you already match your own positive descriptions of yourself. Take each descriptive word or phrase you have used to describe yourself and, one by one, make it real by acting and reacting with the mannerisms of someone you have seen who has that characteristic. This makes your self-portrait laugh and breathe.

• Pick a model. If confidence is the quality that you want to recover or develop more fully, pick a model like Mary Tyler Moore or Oprah Winfrey, or someone you know and admire, to help you out. Your own confidence can begin to grow as you imitate them.

• Practice your new words, actions, and attitudes. Preplay your act in your mind until it feels like second nature to you. Visualize yourself going through the motions of acting as a confident person.

• Try out your new skill. When you are in a store, pick someone on whom to try out your new Self, like a clerk who never saw you before. She won't know whether you are more or less confident in your manner than you had been, but with each try your confidence can increase.

• Repeat to gather more skill. Choose other attributes that you need, one by one, and act as if they are already a part of you. Pick the best model you can think of for each one of them, and imitate her until you've got it.

• Share your new picture. Even though these exercises are only the beginning of your new creation, share your results with other women when you can, and listen to what other women are saying as they define themselves. What you hear will give you ideas about other touches you want to add to your own picture.

Dreaming a New Dream

You can use your freshly painted picture to describe yourself as the principal actor in your new dreams. All you need now is the dream. A detailed dream can be one of the most important steps you can take out of your grief and on into a freer life. When you can start looking forward in time and making plans for the future, it is easier to let go of the past.

Using a fresh sheet of paper, and a mind that sees no limits to the choices you have, begin to write down the kind of life you want. Use all the preference lists you made earlier to help you pull together a solid, detailed dream and include what you want to do, where you want to live, who you want in your life, and how you want to be treated. You will find that your lists have a mystical way of expanding. Every time you add one thing it is likely to make you think of something else you had forgotten. Add as much to each list as you can. Use them as a foundation for the solid plans you are making now. And then begin to talk about your dreams out loud with other women.

• Write down your plans. Do you want a bright new apartment? Do you want to go to school? Do you want to find a job, or a different kind of job? Would you like to find some kind of work that pulls you out of bed in the morning with excitement, hope, and anticipation? Would you like to work out an arrangement with another woman to take care of your children sometimes and you take care of hers at other times so you can both begin to fulfill your dreams? While you are dreaming, make it good. Fill in the details and write them all down.

• Add one more list. In addition to the ones describing the details of the environment you want to live in, make a list of the personality traits that are requirements for anyone with whom you choose to have a relationship. State your needs in a positive way, such as, ''I want someone who has an even temper,'' ''In addition to loving, I need someone I really like and who likes me,'' or ''I want someone who is on my side and whom I can

freely support." Make your list as long as you want and keep adding to it.

If you are not a resident in a shelter at the time you need help to deal with your grief, you can join a group that is run by shelter personnel or one that is recommended by the shelter, and take advantage of the help you can get from the expertise of the advocates and the experience of the other women. In this way you can find a starting point and the support you need to begin to make your dreams come true.

Get All the Help You Need—It's Important to Take Grief and Depression Seriously

You will have done a lot for yourself when you have begun to fill in the blanks in your definition of your Self, begun to dream again, found ways to come out of your isolation and to deal with your denial and self-anger. But each woman may have her own unique problems with separation from an abusive partner, or leaving a violent relationship. Allow yourself to get all the help you need for as long as you need it. Use the groups that are available to you, but also ask for a reference to the best private professional counselor that you can afford. You are dealing with grief, depression, possibly posttraumatic stress syndrome, and other effects from living in an abusive environment, and you can't afford to treat them lightly.

Annette's Story

Annette's story shows how profoundly a woman can be affected by grief as she separates from an abusive partner; and the way she can recover from it. When she first separated from Charlie, her abusive husband of over twenty years, all but one of Annette's three children were grown and on their own. She thought she "had it made." The divorce was her idea, but she was feeling depressed much of the time afterward and began to

drink more alcohol than she had in the past. The crisis came when she woke as if from a dream and found herself chasing her young son with a knife. Horrified at her own behavior, she gratefully asked Caroline for help one day when she came to Annette's door to offer it. Caroline was the wife of one of her husband's friends. She took Annette to a doctor and helped her in many other ways.

Medical doctors and psychiatrists tried to help Annette. But she did not respond to them. She refused to take the medication they prescribed for her. She retreated deeply into her own mind where no one could reach her. Doctors finally transferred her to another hospital. Looking back later, Annette was convinced that her doctors had given up on her then.

Soon, the nurses caring for her began to wheel her out into a spacious open room and leave her in her wheelchair in front of a window that looked out on a huge tree. Little by little, Annette said, she began to notice the magnificence of that tree. When a nurse came to get her, she declined and insisted on staying by the window. It was the first reaction anyone had seen from her in many weeks. Each day, she stayed in front of the window for as long as they would let her sit there. She doesn't remember how long it was before she started to concentrate all of her attention on the tree; to think about how much she related to it and admired it. Some days it was storming and sometimes the weather was hot and sunny. Annette thought about how resilient the tree was; how it withstood all kinds of weather and each day looked even more beautiful than it had the day before. She listened to the wind blowing through the leaves and felt a fresh breeze waft through her mind. She noticed how strong and firmly rooted the tree was and how the leaves and the branches easily returned to their natural position even after a raging storm; being no worse for the experience. She began to relate to the sturdy tree so powerfully that she felt that she, too, could withstand anything; that she was strong and firmly made, like the tree. She said, "I just . . . put all my soul into that tree."

Annette looked the same to other people as she had when she

was first admitted to the hospital. No one had any idea what was happening to her. But they were beginning to notice a new sparkle in her eyes. They could see that she wanted to get up out of her bed and out of her chair. She began to want to talk, first to the other patients, and then to the nurses and doctors. She spent another month in the hospital. But she was on her way to complete recovery.

The last time I saw Annette she was successfully finishing a degree in counseling and looking forward to working with women who had been abused as she had been. She walked tall and straight, wearing her confidence like a crown. She'll be an asset to many women as she reaches back and gives them a hand out of their isolation and abuse. Just one of the things she'll be able to do is to tell them about her grief and how she came out of it.

SECTION V

FOLLOWING UP

Following Up: Becoming the Woman You Want to Be

When I remember Wilma, I know that what I have said here is inadequate for some women. Wilma was in her sixties when I met her. She had escaped, somehow, from her prison on the third floor of her own home. She had been locked up there for years by her husband, who fed her by having small meals delivered to her several times a day. We never knew the details of her captivity or her escape. She was found wandering the streets and taken to a shelter by the police. She was frail, intelligent, sweet, and loving; anxious to participate in the world and to be of some use to it. There is no way to know how many Wilmas there are who cannot be seen. I can only hope that there is at least one person in every hidden woman's life who knows where she is and is willing to contact a hotline to find out if there is any way she can be helped.

What I have written may seem inadequate for other women too. For there are some relationships in which there is no gradual progression; there is no early courtship phase in which to fall in love. There are some abusive men who insist on complete control from the beginning and who are immediately violently abusive. They are so frightening and intimidating and cruel that getting away from them depends on having a lot of

outside help and is imperative if their female partner is going to survive.

If this sounds like your partner, waste no time. Get to a phone somehow and call 911 or the police and insist on their help in getting you to a shelter, and with their help go from there and follow their advice every step of the way. If you know such an abused woman, call the hotline yourself and find out if there is any way you or someone else can help. When the danger from her abusive partner is so great for her, it will be just as dangerous for anyone who tries to help her.

Sometimes, to other women, the suggestions I have made may have sounded glib or trite, as if I think they are easy. I don't. But there may be times when I have overestimated the power you have, because I can't guess the seriousness of the situation you are in. I know that many of you live in despair and pain from physical battering, verbal abuse, isolation, and terrorism beyond many people's imagination. Still, your power can grow. That is why I have deliberately focused on you and the power you have to nourish yourself and to change your life rather than on what is being done to you by someone else. I hope that makes it easier for you to turn away from the source of your pain and focus on solutions.

You will need, at some time during your continuing self-discovery, to talk with other people about what has been done to you by someone you loved. You need to be validated and to comprehend the extent of the abuse you have absorbed from your partner, and the effects it has had on you. You need to rage and to cry if you feel like it. You need help to ease your pain, anger, and resentment. You need to recover from the effects of the heightened levels of stress with which you have lived. But this will be a gradual process and, for a time, will continue alongside your pursuit of new dreams.

Again, you need to clearly understand that the damage that has been done to you is not your fault. It is the fault of an abusive person who will treat in much the same way the next woman he isolates in a relationship.

No, it is not your fault. But now that it has happened, it is up to you to take whatever steps you can to see that it doesn't keep on happening. Now you have started to think about your life in a new way; you have a new focus for hope—yourself.

Now What?

Each person creates her own way of marking the world with her presence; finding the place where she can give to it and receive from it at the same time; finding the way to live that is best for her and for others as well. The path you choose to take will be unique to you.

The job you have to do now is the same as it was before you broke free: continue to increase your level of awareness about your life and where you want to take it, find ways you can stay safe, and rediscover your Self. You are the only one who can begin that task. Let everything you do now help you decide that your freedom and opportunity to discover your Self and what you can be and do is what you want more than anything else in life.

The Importance of Other People—a Few of Your Choices

First, realize the importance of other people in your efforts to stay free. Not even a superwoman could come out of a painful life with an abusive partner and stay free without help. Underlying every suggestion reviewed below is the warning to stay out of isolation. Most of these suggestions obviously involve one or more other people.

I've known women who have escaped domestic violence for good without going to a shelter, but all of them found a strong support group or appropriate long-term one-on-one counseling, or both. Sometimes *group* meant one woman at a time chosen out of those she met; sometimes it meant finding a more formal group to meet with on a regular basis; and sometimes it meant

that even one family member had learned about domestic violence and found out how to be supportive of a daughter, sister, mother, or other female relative who wanted to free herself.

Without contact with other people who are learning how to make changes in their own lives, you may fall back into isolation, despair, and loneliness. Frequent reminders from your contacts can light your path and keep you on track. No matter how sure of yourself you get to be, you will always need other people and more reminders. We all do. The learning doesn't need to be complete to be effective. The adventure continues.

Dorothy was one of the women I talked with at a shelter for battered women. She had been there ten years earlier. With the help of a dedicated staff she had rebuilt her Self and her strength. She divorced her husband, gained custody of her children, and stayed safe and free for a few years.

Then she drifted away from her supportive women friends and from her contact with shelter personnel. She forgot what she knew about abusive men and fell deeply in love very quickly with a physically abusive man who first isolated her with his possessive attention. She had been married to him for several years when I met her. Then she needed to find her way to freedom again.

Dorothy's story shows how easy it is to fall back into another abusive relationship. Please believe me when I say that it can happen to any of us at any time! Many women with whom I talked were in a shelter for battered women for the second or third time. If you let go of the other contacts you have formed, the possessive exaggerated attention of a new abusive man can make you think he's just what you need. Yes, it could happen again.

It's time now to review and expand your contacts with other people; to keep on learning what your life is for; to think about how you can use the tough experiences you have had to help other people, if you want to do that. There are no limits to how your life can expand. Stay involved and keep on expecting the

best for, and of, yourself and watch one accomplishment lead to another.

Even if you are still living with an abusive partner, check over the following list—see if there is anything on it that you can *safely* do now; and then do it.

If you have separated from your abusive partner, but things are not going as well as you think they should, don't give up on yourself! And *even when things are going well,* continue to do the following:

1. Find and join a support group for battered women. Keep in touch with the battered women's hotline or advocate/counselors at the shelter. Ask for referrals to ongoing support groups for women who have been hurt by a partner, and then go to them on a regular basis.

2. Attend Al-Anon group meetings. Even though I've mentioned them before, it is valuable to repeat the suggestion, because the messages spoken at these meetings are reminders you cannot afford to forget. It is here you find the continual emphasis on the power you have when you focus on yourself. It is here that people will talk about what they want in their lives and how they intend to get it, while they prod others into remembering what they want too. Even if you have a support group for battered women and a substitute family, visit an Al-Anon group if you are suffering from the lingering effects of living with someone who has been abusing alcohol or other drugs. There will be other women there who have suffered from abuse, because the heavy use of alcohol usually makes verbal abusers out of most people, and directly and indirectly fuels physical violence as well. Choose one or more women as your sponsors so you can talk to them on the telephone, or meet them in person, when you need to consult them between meetings.

It's okay if all you can do at first is just walk into the room, sit down, and listen. Participate only when you are ready. If there is more than one group in your area, choose the one in which you feel most at home, where you can relate to the things

you hear other people say. Visit the same group at least six times before you decide whether or not you want to continue. Choose the group in which the members have the longest and deepest experience with methods of self-discovery. When you hear members talk about how they are making their own choices and living one day at a time, keep coming back. You will find there is no end to what you can learn.

3. Consider joining a therapeutic group. If you need a therapeutic group to deal with lingering emotional scars, choose one that lays out the purpose of the group and how it will function; one where the group leader has a thorough understanding of the issues of abusive relationships as well as of group dynamics. Again, get a recommendation for an appropriate group from the hotline for battered women, the rape crisis center, or other crisis-oriented organizations.

4. Look for effective one-on-one counseling. Group work may not be the best, or only, route for everyone to take. If you feel you would benefit from one-on-one counseling, ask the battered women's hotline to recommend the appropriate expert for you to work with.

5. Stay in contact with your substitute family. The people you have chosen as your support system are valuable additions to your life. You don't ever have to give them up. Even after you have broken free from an abusive relationship, you may not be ready to reunite with your original family. If your family is still not strongly supportive of what you are trying to do, postpone your family reunion. Is your family trying to understand domestic violence? Or are they still blaming you, even in subtle ways, for the abuse you have suffered? If they are, maintain your emotional distance from them a little longer.

6. Improve your physical health. It is an important way to get and maintain the stamina you need to build your life according to your plans. It's the foundation for everything else you want to do.

7. Nourish your spirit. It has been badly damaged. Use whatever method fits your beliefs and your lifestyle. Find out what

works for you. Meditation and/or prayer, or attending religious meetings of your choice, are effective for some women. Nature and music have calming and exalting effects. Spend time with both of them when you can. Volunteer to help women who are just coming into a shelter or who are calling the hotline for help; find a way to share what you've learned.

Creativity is the vehicle some woman ride into a new future, and it is one of the best ways to nourish your spirit and rediscover yourself. Focusing your attention, using your imagination, creating something new and beautiful—all can enhance your ability to keep in touch with and use your inner resources.

8. Keep a journal. Continue to write in your journal whenever you can. There are courses in journalizing given at junior colleges and sometimes at bookstores. They can be useful and inspiring. Take advantage of them. If you are still living with an abusive partner, work on your journal in a safe, private place.

9. Stay vigilant. Life will lead you to other ways that will inspire you to break out of your isolation and to stay out of it. Soon, you will find a new focus of interest and purpose for your life. Once you have set your course and committed yourself to it, you are likely to find whatever it is you need to keep going.

10. Eliminate barriers. Unless you recognize each barrier that confines you or holds you back—unless you open your mind to the limitless possible paths you can take into the rest of your life—you may find yourself confined again by the weight of your own thinking.

Lack of your own independent source of money, whether it is a job or a bank account, is a real problem, and is one of the strongest barriers women see to their freedom from dependence on an abusive man. But women who have their own money, or know where to find it, often still do not leave an abusive relationship.

You are building a barrier when you say, "But I can't leave. I have no money. I have never supported myself before and I have no work experience. I am too old, no one will hire me. I am too young." One day in the shelter Francine told me that

she thought she was too old, that it was too late for her to find gainful employment. And yet she was only twenty-five years old. And there are many women who suffer in abusive relationships who are in their fifties and sixties and beyond. It's the contacts you make that are important and that lead you forward. Don't let your own mind get in your way. If you are not physically or mentally handicapped in any way, it is only your own mind that stops you. And many handicapped people ignore the obstacles and often are quite successful, with a lot of help from other people. You can take the following steps toward financial independence:

• Get your own bank account. Open a bank account in your own name, or with a trusted relative or friend who will treat it essentially as yours, and just use her name for a cover, if you need it. Do this even if you have only fifty dollars or less to start with. Add to it when you can, even when you think the amounts you add are too small to do you any good. It could add up to a fund big enough to help you out in an emergency.

• Take a course. It can be a course that will finish a high school or college diploma or degree, or one that will give you a new, employable skill or let you brush up on an old one.

• Look for help from a ''reentry'' program for women. There are well-structured courses and groups in many parts of the country that offer step-by-step instruction for women who have never worked outside of their homes or received a paycheck before. They support you from the first day, through acquiring a marketable skill, to finding work, to the moment you set off for your first job. As a start, try the junior college nearest you. If they don't offer such a course or series of courses, they may be able to tell you where you can find them. Also check with the twenty-four-hour hotline for battered women and ask if they can direct you to a group or organization that can help you reenter life or the job market.

• Volunteer in order to build a skill. There are unlimited opportunities to volunteer in organizations where you can

gather the experience you need to find a job later, possibly even in the place where you are volunteering. A shelter for battered women is one place to start. Your personal experience with an abusive relationship and recovery, along with additional training, can eventually make you a valuable addition to the staff.

• Welfare. Most women use welfare funding, food stamps, hospitalization or medical cards, paid child care, and scholarships as temporary measures until they can provide for themselves.

Use one of your groups, a new friend, or a one-on-one counselor to help you to eliminate other barriers to your new freedom—barriers that you see for yourself, or that they see for you.

11. Heal first, then look for a new relationship. Another barrier to your freedom is the belief that you can't leave your abusive partner until you have another relationship to step into. It is important for you to postpone a long-term relationship with a new man until you've met your Self and really know what it is you are looking for in a man or in a relationship. When you have gotten to know yourself better, you might choose an entirely different partner than you would select if you were to jump into another relationship before your wounds have at least begun to heal.

What Are the Sources of Your Greatest Power?

Advice given in some self-help books is "You have to work hard to get what you want." Let me offer you an alternative. Sometimes you find your greatest power when you are able to release your effort. Stop trying so hard. When you learn to relax, new answers will present themselves to you. When you try too hard you sometimes stay focused on the negative aspects of what you are trying to do. Sometimes a life can change in a flash of realization that alters your perspective on yourself and others around you. It needn't always take years for your perspective to change or for your life to turn around.

Relaxing and releasing your exhausting efforts to change someone else is not to be confused with quitting. When things don't seem to be working as you want them to, back off for a little while, take another look, and begin again at a different pace, or a different place.

Sometimes taking another look means noticing the small glow of what's left of your Self, and turning that glow into a flame until its light is all you can see. Selves seldom disappear completely. The small glow that is left is like a pilot light that has been dimmed and diminished, sometimes almost into non-existence. It doesn't mean you can't find the dial to turn up the flame. And from that flame you can light as many other fires as you wish. As your strength and determination grow, that flame can go higher and higher; so high, you will never want to take a chance on diminishing it again.

You can also gain more inspiration and energy when you learn specifically where your power lies. Then you will know where to concentrate your efforts and your energy. When you find yourself getting tired or discouraged, consult the following list and find out if you are using your energy where it will do the most good, or sapping your energy by tackling projects where you have little or no power (such as in trying to change someone else).

Your power is greatest when you:

1. Live in the present moment. It is the only time you can really change anything: what you eat, what you say, how you interpret the words or deeds of another person, or how you react. Living with your full attention on the present moment eventually changes both how you feel about your past and what you dare to dream of for your future. You can do nothing about your past actions, except to learn from them and change your interpretation of them. You can change the guilt you feel about the past only by what you do in the present. Your fear of the future has no meaning, except to warn you to take all possible precautions to stay safe. But you can only do that in the present

moment. Do what you can to plan for your future and then let it go in favor of taking the action today that will eventually accomplish your plans. Save your energy for what you can do now while, at the same time, holding on to your awareness of the world around you.

2. Question your beliefs. Just a few examples of the restricting beliefs many women hold are: 1) that women are, by themselves, responsible for the quality of all family relationships; 2) that there must be a man in your life in order for you to be happy and for you to find your identity; 3) that being alone means being lonely and is something to be afraid of; 4) that he will change if you just learn to be perfect; 5) that you can find some way to influence him to change and then your life will be perfect; 6) that you need permission from someone other than yourself to be happy.

When you can set aside your own deeply held beliefs about yourself and your partner, you can gain a new perspective. A new perspective minus old beliefs equals new possibilities as your mind opens up to your true place in the world.

3. Stay in touch with your own mind and Self. Women use prayer, meditation, reading on their own, formal learning, connecting with others in many ways, creative activities, or a satisfying work experience to bring themselves to peace, self-trust, and self-determination. You are your most powerful and knowledgeable ally. You know more about yourself than anyone else does. Consult and trust yourself.

4. Take full responsibility for the quality of your life. When you stop blaming others for the problems in your life (although, yes, it is his fault that he hits you, not yours), you can focus on taking positive actions to solve them. If there is something you don't like about your own life, you are the only one who can change it.

5. Understand that change is a joy. Changes made in joy, rather than as a burden or a duty, can become part of you more easily and encourage the next shift in your life direction.

6. Know that one thing leads to another. When I asked Helen

why she wanted to go back to school to get a master's degree when she would be fifty years old by the time she finished, she said, "I'm going to be fifty years old in three years anyway, why shouldn't I have my master's degree when I get there? Then I'll see what's next." Your dreams begin to come true from the moment you start to build them—from the efforts you make today.

When you look at a big job all at once, it can be overwhelming. But when you take the first step and then look only at step number two, you can see that it's doable. Take small steps for as long as you need to. Make one phone call. Talk to one person you might not have spoken to. Sometimes one phone call can lead to valuable contacts you would not have thought of otherwise. Each thing you do leads to the next and makes the following one easier.

7. Think for yourself. You can listen carefully to everything other people have to tell you, but you are the one who lives with the consequences of what you decide to do. If a traditional-minded parent tells you it is your duty to go back to the man who has beaten you, ask yourself if that is really what you want to do. No one else walks in your shoes. Your parent isn't the one who takes the consequences of your actions; you are. If your parent does not support what you want to do, talk with someone who does.

It is your own mind that needs to determine the actions you take. In turn, your actions can reflect your emotional strength back to you when you make the right choices. How will you feel if you return to your abusive partner? When you refuse to go back?

8. Learn what brings you peace:

- Accept other people and circumstances as they are after you have made whatever changes you can.
- Little by little, change what you need to change about yourself.

- By focusing on yourself and on the present moment, learn where to concentrate your efforts.

Gradually, you will become unwilling ever again to stay in an environment where all of your energy is used only to survive. Soon, you will make choices that move you toward peace as a sunflower follows the light.

It doesn't matter where you have been, who you have been with, what you have done, or what has been done to you, you have a right to reframe your thinking, your Self, and your life.

Here are just a few of your rights as a person who is newly discovering her Self and is recovering from life with an abusive person. It's easy for me to list these rights for you, but it will be up to you to make them part of your life.

Bill of Rights

You have the right to change the direction, the tone, and the purpose of your life.

You have the right to avoid contact with anyone who is not truly on your side, no matter how closely related to you.

You have the right to ask that anyone who helps you must keep your best interests at heart and understand your situation, as you will understand hers.

You have the right to a relationship free from every kind of abuse.

You have the right to develop a clear sense of what you want your life to be and then live it.

You have the right to ignore what other people think of you.

You have the right to express your feelings, ideas, and opinions. You have a right to express your Self.

You have the right to be physically and emotionally safe and free of fear in your own home.

You have the right and responsibility to pursue a pur-

poseful life; to use all you've learned to help the world understand domestic violence, no matter what else you decide to do.

You have the right to live.

My hope is that you can now disentangle yourself from the web in which you may be caught; and that you will be able to see the next web more clearly and can choose to pass it by on your way to a life of your own creative design.

BIBLIOGRAPHY

This short list of books and tapes is basic. It is meant to give you a toehold, a way to help you take your first step on a new path. It is a mixture of academic and popular references. These references will lead you to others.

Books for Women Who Are Living, or Have Lived, in an Abusive Relationship

Evans, Patricia. *The Verbally Abusive Relationship: How to Recognize It and How to Respond.* Holbrook, Mass.: Adams Publishing, 1992. Reading this book can show you that many women share your experience of thinking you are alone and at fault for your own abuse.

_____. *Verbal Abuse Survivors Speak Out on Relationship and Recovery.* Holbrook, Mass.: Adams Publishing, 1993. Deepens and further illustrates the material presented in her first book.

Jones, Ann, and Susan Schechter. *When Love Goes Wrong: What to Do When You Can't Do Anything Right.* New York: HarperCollins, 1992. A comprehensive workbook for both victims of violence and those who help them.

NiCarthy, Ginny. *Getting Free: You Can End Abuse and Take Back Your Life.* Seattle: Seal Press, 1986. Used effectively by many abused women and advocates since 1982 version.

_____. *The Ones Who Got Away: Women Who Left Abusive Partners.* Seattle: Seal Press, 1987. Inspiring and hopeful.

Women's Issues and Self-Development (Books and Tapes)

Branden, Nathaniel. *The Disowned Self.* Los Angeles: Nash Publishing, 1971. Self-development and self-esteem are treated with a multidimensional approach so that we can use the information to help us know how to live.

_____. *The Six Pillars of Self-Esteem.* New York: Bantam Books, 1994. Clear descriptions of the foundations of self-esteem and how to build them, from a master in the field.

Helmstetter, Shad. *The Self-Talk Solution.* Studio City, Cal.: Dove/ William Morrow Books on Tape, 1988. Inspiring account of how self-talk impacts our lives.

_____. *What to Say When You Talk to Yourself: The Major New Breakthrough to Managing People, Yourself and Success.* Scottsdale, Ariz.: Grindle Press, 1986. Instructions on the importance and the techniques of self-talk.

Jack, Dana Crowley. *Silencing the Self: Women and Depression.* New York: HarperCollins, 1991. Demonstrates prevalence and origins of depression in women. We hear the voices of her subjects. Valuable.

Kabat-Zinn, Jon. *Full Catastrophe Living: Using the Wisdom of Your Body and Mind to Face Stress, Pain and Illness.* New York: Delacorte Press, 1990, 1991. Practice in meditation and relaxation.

_____. (1994). *Wherever You Go, There You Are: Mindfulness Meditation in Everyday Life.* Audio Renaissance Tapes, a division of Cassette Productions Unlimited, Inc. 5858 Wilshire Boulevard, Suite 205, Los Angeles, CA. Comprehensive, but down to earth. Simple instructions that demystify the use of meditation to enhance our ability to live more effectively.

Sher, Barbara, with Annie Gottlieb. *Wishcraft: How to Get What You Really Want.* New York: Ballantine Books, 1979. Shows you ways to find out what you want.

Steinem, Gloria. *Revolution from Within: A Book of Self-Esteem.* New York: Little, Brown and Company, 1992, 1993. Comprehensive in covering women's issues; gives a hand up in self-development. Valuable. Extensive bibliography and notes.

Williamson, Marianne. *A Woman's Worth.* New York: Ballantine Books, 1993. Women given responsibility and privilege of creating their own lives.

Academic References

Caesar, P. Lynn, and L. Kevin Hamberger. *Treating Men Who Batter: Theory, Practice, and Programs.* New York: Springer Publishing Company, 1989. Academic report on approaches to research and results of studies of abusive men. It covers feminist, cognitive-behavioral, family systems, and integrative approaches.

Gelles, Richard J., and Donileen R. Loseke, eds. *Current Controversies on Family Violence.* Newbury Park, Cal.: Sage Publications, 1993. Valuable reference and overview of the field of domestic violence.

Herman, Judith Lewis. *Trauma and Recovery: The Aftermath of Violence—from Domestic Abuse to Political Terror.* New York: Basic Books, 1992. Emphasizes importance of expertly integrating personality of abuse survivors. Academic, but easy to read. Valuable. Excellent bibliography and index.

Sieburg, Evelyn. *Family Communication: An Integrated Systems Approach.* New York: Gardner Press, 1985. Clear descriptions of communication in closed, rigid family systems.

Books about Alcoholism and Its Effect on Families

Black, Claudia. *It Will Never Happen to Me: Children of Alcoholics as Youngsters—Adolescents—Adults.* Denver: MAC Publishing, 1981. Classic reference; explains development of rules and roles in alcoholic families.

Gorski, Terence T. *Do Family of Origin Problems Cause Chemical Addiction?: Exploring the Relationship Between Chemical Dependence and Codependence.* Independence, Mo.: Independence Press, 1989. Small, powerful book; summarizes major studies in the field of alcoholism.

Johnson, Vernon E. *I'll Quit Tomorrow: A Practical Guide to Alcoholism Treatment.* San Francisco: Harper and Row, 1980. Classic reference; explains denial and development of tolerance to alcohol.

Other Related References

Frankl, Viktor. *Man's Search for Meaning: An Introduction to Logotherapy.* New York: Pocket Books, 1963. A demonstration of human ability to survive three years in a concentration camp

while maintaining personal integrity, and how that integrity was basic to Frankl's survival.

Fromm, Erich. *Man for Himself: An Inquiry into the Psychology of Ethics*. Greenwich, Conn.: Fawcett Publications, Inc., 1947. Fine discussion of ideas about selfishness and selflessness. Speaks of confusion on this issue among various philosophies.

Redfield, James. *The Celestine Prophecy*. New York: Warner Books, 1993. Fictional description of how our actions and reactions can build our private world; and how what's best for us is also best for others.

KEEP IN TOUCH

Dear Reader:

Your comments or stories about your own experiences within an abusive relationship, or on anything that has been said in this book, are heartily welcome. I may not be able to answer each comment, but I will eagerly read each word you have time to write to the following address:

Ruth Morgan Raffaeli
P.O. Box 843
Strongsville, OH 44136

When you write it would be helpful if you could tell me your age, your gender, and your relationship to the person who is abusing you; also his or her age and gender, and the length of time you have been in an abusive relationship.

If anything you have read here has helped you, please tell me exactly how it helped. Let me know what action you have been able to take, or are planning to take, because of it. If something I have suggested has not worked for you, please be sure to tell me that also, and to share your own suggestions with me.

Please tell me, too, about any methods you have used to stay safe.

Thank you,

Ruth Morgan Raffaeli

Resources: Where Can You Call for Help?

To get help when you are hurt or in danger of being hurt by an abusive person:

1. Call 911. Try to stay on the line until you have given complete information about where you are and the kind of danger you are in. Stay as calm as you can.

2. Call your local police department when you do not have 911 service in your area. The number is (write the number here):_____.

3. If 911 is not available to you for any reason, and you do not know the number of your local police department, dial 0 for operator, give the location and the telephone number where help is needed, and stay on the line if at all possible. Telephone companies do not generally guarantee that help will arrive under these circumstances.

The national hotline number is: (800) 799-SAFE. Call it when there is no hotline in your area, or to find out where the hotline or shelter is that is nearest to you.

How to get in touch with your local hotline (to get access to a shelter or to get information about domestic violence).

1. Call local information and ask specifically for the hotline number for domestic violence. The number is (write the number here):_____.

2. Or, look in the back part of the white pages, in the blue pages, and in the yellow pages of your telephone books under any of the following headings in different cities: "Abuse," "Battered Women," "Domestic Violence," "Family Violence," "Crisis Line," "First Call for Help" (or "United Way First Call for Help"), "Counseling," "Family Counseling." In many cities check the "Community Service" listings in the front section of the white pages. The hotline can furnish you with information regarding shelters, and answer your questions about domestic violence. Memorize the number, but also write it down here. It is:_____.

Getting in touch with a hotline at the state level (for information or referral to a hotline or shelter in your area): Circle your state number.

These numbers can be reached only when you are calling from within the state listed. Even though some services are available twenty-four hours a day, call between the hours of 9:00 A.M. to 5:00 P.M. to be assured of getting direct service.

DOMESTIC VIOLENCE HOTLINE NUMBERS BY STATE

State	Hotline Number	Coalition Number
Florida	(800) 500-1119	(904) 668-6862
Indiana	(800) 332-7385	(317) 543-3908
Iowa	(800) 942-0333	(515) 244-8028
Maryland	(800) MD-HELPS	(301) 942-0900
Nebraska	(800) 876-6238	(402) 476-6256
New Hampshire	(800) 852-3388	(603) 224-8893
New Mexico	(800) 773-3645	(505) 246-9240
Nevada	(800) 500-1556	(702) 358-1171

New York	(800) 942-6906	(518) 432-4864
North Dakota	(800) 472-2911	(701) 255-6240
Ohio	(800) 934-9840	(614) 784-0023
Oklahoma	(800) 522-9054	(405) 557-1210
South Carolina	(800) 260-9293	(803) 750-1222
South Dakota	(800) 430-SAFE	(605) 945-0869
Tennessee	(800) 356-6767	(615) 386-9406
Utah	(800) 897-LINK	(801) 538-4100
Virginia	(800) 838-VADV	(804) 221-0990
Washington State	(800) 562-6025	(360) 352-4029
Wyoming	(800) 990-3877	(307) 857-0102

For professionals and individuals looking for information about domestic violence, contact: The Domestic Violence Resource Network in Harrisburg, Pennsylvania, at (800) 537-2238. Fax (717) 545-9456. When you call these numbers you may be put into voice mail, where you can leave a message. Someone will call you back at the first opportunity. These numbers are not designed for emergencies, or as crisis or counseling lines. They are furnished to provide information.

This organization provides comprehensive information and resources, policy development, and technical assistance designed to enhance community response to, and prevention of, domestic violence, and includes the following special departments providing assistance with specific problems relating to domestic violence:

1. Battered Women's Justice Project. (800) 903-0111
• *Domestic Abuse Intervention Project.* Fax (612) 824-8965.

Addresses the response of the criminal justice system to domestic violence, including development of programs for batterers.

• *National Clearinghouse for the Defense of Battered Women.* Fax (215) 351-0779.

Addresses issues raised when battered women are accused of committing crimes, including killing an abusive partner.

• *Pennsylvania Coalition Against Domestic Violence.* Fax (717) 671-5542.

Addresses civil court access and legal representation issues of battered women.

2. Resource Center on Child Protection/Custody in Reno, Ne-

vada. (800) 527-3223. Fax (702) 784-6160. Provides resource materials, consultation, technical assistance, and legal research related to child protection/custody in the context of domestic violence.

To get help locally for a problem with substance abuse or addiction:

Look up the local number for **Alcoholics Anonymous,** usually in the back of the white pages of your local telephone directory. The number is:_____.

Also look under "Alcoholism" or "Alcoholism Information and Treatment Centers" in your yellow pages, and under "Alcohol" in the back of the white pages.

Listings under this heading also offer information about addiction to other mood-altering substances.

The number I have chosen to call is:_____.

If you are being hurt by someone else's use of a mind-altering substance, call: Al-Anon Information Office (also use this number to find out where meetings are held for affected family members who are ages eight through eighteen, Al-Atot and Al-Ateen). In the back of the white pages of the telephone book.

The number is:_____.

For a national resource that can provide you with information regarding Alcoholics Anonymous, call or write:

Alcoholics Anonymous World Services
P.O. Box 459
Grand Central Station
New York, NY 10163
(212) 870-3400

For a national resource number to get information regarding Al-Anon, including how to start a meeting if there is none in your area, call or write:

Al-Anon Family Group Headquarters, Inc.
1600 Corporate Landing Parkway
Virginia Beach, VA 23454

(804) 563-1600

Hotline (to find meetings in your area): (800) 344-2666, between 8:00 A.M. and 4:00 P.M.

Neither the author of this book nor the publisher can be responsible for any claims of services made by programs listed, nor for the quality of services provided.

ACKNOWLEDGMENTS

Thanks to Dr. Jean Dobos for guiding my original research from beginning to end and for suggesting I write a book. Thanks to Dr. George Ray for methodological and philosophical guidance, and to Dr. Willis Sibley for adding a different perspective.

Thanks to my friend Ruth Harris for suggesting my thesis might be a book and for reading each original chapter as it was written and offering valuable suggestions. To Willetta Thomson, Virginia Colahan, and Pat Dubecky for reading and critiquing early versions. To Willmetta Brown for checking a later version and for many years of friendship. All provided valuable expertise and support.

Thanks to Annette Cooper for keeping me by her side so I could try to emulate her skill and knowledge; for showing me how to stay calm in a crisis and for enduring friendship. Thanks to Joan Helbig and Sheila Turner, who helped me see new perspectives in what I was hearing. To Joan Donnell, Rene Benns, and Dawn Gargiulo for their unending willingness to answer my questions; to Susan Petrarca for making me feel at home; to Lee Evans for sharing important research I could not have found otherwise; and to many others who generously shared their expertise.

Thanks to Glen Broz for his generosity, wise advice, and counsel.

Thanks to my literary agent, Liz Fowler, for connecting me with Bantam Doubleday Dell and for providing professional guidance and editorial expertise.

Thanks to editor Trish Todd for suggesting and accepting the present format of this material; to editor Stephanie Gunning for finding important gaps in my writing and gently telling me about them; and to editor Mary Ellen O'Neill for expertly carrying the book through the process of production.

Above all, I want to thank the women and men who generously shared their personal stories. Their words were freely expressed to me directly from their hearts and their souls. They made it possible for me to understand abusive relationships from the inside out.

INDEX